# Walt Disney's ALICE in Wonderland

An Illustrated Journey Through Time

Mark Salisbury

Foreword by Kathryn Beaumont, as told to Mindy Johnson
Introduction by James Bobin

A WELCOME ENTERPRISES BOOK

LOS ANGELES ❋ NEW YORK

Copyright © 2016 Disney Enterprises, Inc.

The following are some of the trademarks, registered marks, and service marks owned by Disney Enterprises, Inc.: Audio-Animatronics® Figure, Disney California Adventure® Park, Disneyland® Hotel, Disneyland® Park, Downtown Disney® District, Fantasyland® Area, FASTPASS® Service, Imagineering, Imagineers, Magic Kingdom® Park, Main Street, U.S.A.® Area, monorail, Tokyo Disneyland®, Walt Disney World® Resort, World of Disney® Store.

Academy Award® and Oscar® are registered trademarks of the Academy of Motion Picture Arts and Sciences.

Hudson trademark of Chrysler LLC.

Jell-O © 2015 Kraft Foods. All Rights Reserved.

All rights reserved. Published by Disney Editions, an imprint of Disney Book Group. No part of this book may be reproduced or transmitted in any form or by any means, electronic or mechanical, including photocopying, recording, or by any information storage and retrieval system, without written permission from the publisher.

For information address Disney Editions, 1101 Flower Street, Glendale, California 91201.

Editorial Director: Wendy Lefkon
Editor: Jennifer Eastwood

Produced by Welcome Enterprises, Inc.
6 West 18th Street, New York, New York 10011
www.welcomeenterprisesinc.com
Project Director & Designer: H. Clark Wakabayashi

This book's producers would like to thank Jennifer Black, Eric Boyd, Fox Carney, Monique Diman, Dennis Ely, Ann Hansen, Winnie Ho, Warren Meislin, Betsy Mercer, Scott Piehl, Steve Plotkin, Michael Serrian, Betsy Singer, Jill Sherwin, Muriel Tebid, Marybeth Tregarthen, Mary Walsh, Dushawn Ward, and Jessie Ward.

ISBN 978-1-4847-3769-9
FAC-038350-16015
Printed in China
First Edition, April 2016
10 9 8 7 6 5 4 3 2 1
Visit www.disneybooks.com

Acknowledgments
The author would like to thank Jessica Bardwil, Becky Cline, Jennifer Eastwood, Dominique Flynn, Dale Kennedy, Kevin Kern, Ryan Lattanzio, Frank Reifsnyder, Jill Sherwin, and his mum.

Image Credits:

Artwork courtesy Animation Research Library on pages: 1, 5, 6, 9, 31, 46–48, 50, 52–59, 64–69, 75–77, 80, 82–93, 98, 100–107, 109, 112–115

Artwork courtesy Resource Cafe on pages: 63, 79, 110–111, 136–137, 176

Artwork courtesy Walt Disney Animation Studios Classic Projects on pages: 12–13, 21–24, 31, 38–39, 40, 42–46, 49–53, 55, 65, 68–69, 76–77, 80, 82–83, 86, 89–91, 98–102, 104–107, 112–114, 116–119

Artwork courtesy Walt Disney Archives Photo Library on pages: 14–16, 18–20, 25–30, 32–37, 41, 55, 65–66, 74–77, 80–81, 83, 85–86, 98, 100, 108–109

Artwork courtesy Walt Disney Imagineering Art Collection on pages: 60–63, 70–73, 78–79, 94–97, 138–139

Artwork courtesy Walt Disney Studios, Franchise Management on pages: 2, 11, 120–123, 125–135, 140–169

Page 17: Portrait of Lewis Carroll (photo), English Photographer, (19th century) / Private Collection / Bridgeman Images

Page 18 (center right): Culture Club/Hulton Archive/Getty Images

Page 18: (bottom): Universal History Archive/Universal Images Group/Getty Images

Page 19 (top left): Alice and Humpty Dumpty, cover illustration for *Alice Through the Looking-Glass* by Lewis Carroll (1832–98), published in London. 1898 (colour litho), Tenniel, John (1820–1914) / Bibliotheque de la Sorbonne, Paris, France / Archives Charmet / Bridgeman Images

Page 19 (top right): Tweedledum and Tweedledee, illustration from *Through the Looking Glass*, by Lewis Carroll, 1872 (engraving) (b&w photo), Tenniel, John (1820–1914) / Private Collection / Bridgeman Images

Page 124: Culture Club/Hulton Archive/Getty Images

Page 131 (bottom left): Illustration from *Alice's Adventures in Wonderland* by Lewis Carroll (1832–98) 1907, Rackham, Arthur (1867–1939) / Private Collection / Photo © Christie's Images / Bridgeman Images

PAGE 1: WALT DISNEY PRESENTS visual development art from the opening of 1951's *Alice in Wonderland*. Artist: Mary Blair. Medium: Gouache, ink, marker.

PAGE 6 (LEFT AND RIGHT): Falling down the rabbit hole background paintings from 1951's *Alice in Wonderland*. Artist: Disney Studio artist. Medium: Gouache.

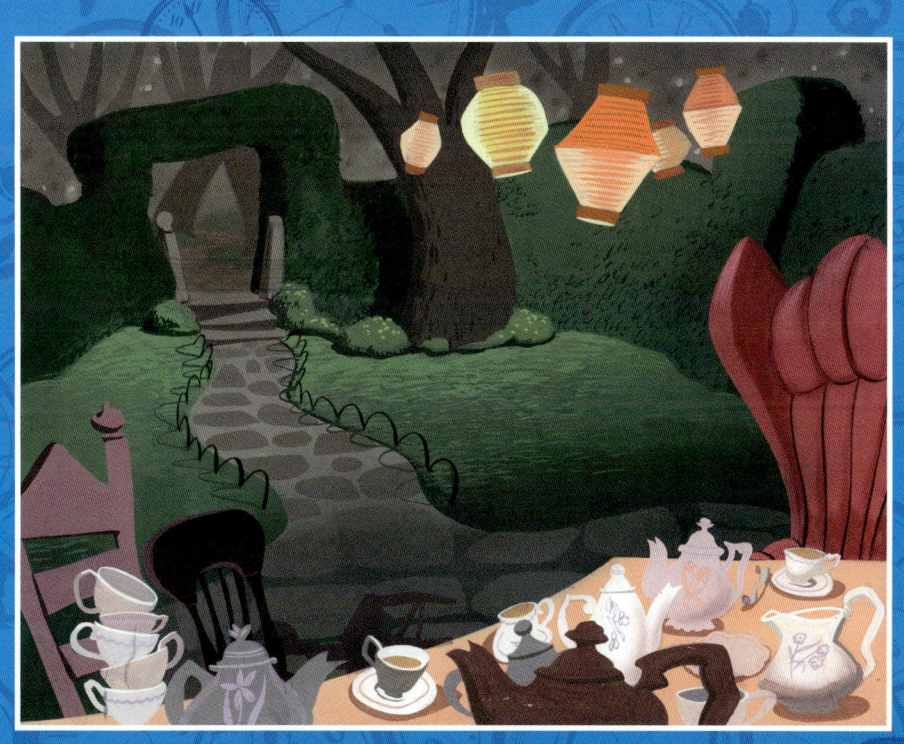

For Laura and Milo,
always there with love, nonsense, and tea.

—M. S.

ABOVE: Tea party background painting from 1951's *Alice in Wonderland*.
Artist: Disney Studio artist. Medium: Gouache.

Contents

Foreword **8** Introduction **10**

1. Start at the Beginning—*The Alice Comedies*
13

2. Everything Would Be Nonsense—*An Animated Wonderland*
44

Shorts: "March of the Cards"—*Thru the Mirror* **48**

Parks: "The Unbirthday Song"—Mad Tea Party Attraction **60**

Parks: "In a World of My Own"—Alice in Wonderland Dark Ride **70**

Parks: "The Caucus Race"—*Alice in Wonderland* Floats in the Main Street Electrical Parade **78**

Parks: "All in the Golden Afternoon"—*Le Labyrinth d'Alice* (or, Alice's Curious Labyrinth) **94**

Television and Other Films: "AEIOU (The Caterpillar Song)" **108**
One Hour in Wonderland
Alice in Wonderland Jell-O Commercial
Alice in Wonderland Hudson Car Commercial
Alice in Wonderland: A Lesson in Appreciating Differences
Writing Magic: With Figment and Alice in Wonderland

Parks: "How D'Ye Do and Shake Hands"—*Alice in Wonderland* Themed Areas **110**

Shorts: "Very Good Advice"—*Donald in Mathmagic Land* **114**

3. Curiouser and Curiouser—*The Live-Action Adventures*
121

Parks: "'Twas Brillig"—Mad T Party Nightly Entertainment **136**

Parks: "Painting the Roses Red"—Alice in Wonderland Maze **138**

Selected Bibliography **170** Index **172**

Foreword

Lessons from Wonderland

To describe what *Alice in Wonderland* has meant to me seems a daunting task, but as Alice herself once said, "there's no harm in trying. . . ." It's always a joy for me to see new generations excited about Alice's adventures in Wonderland after all these years. Lewis Carroll's stories have been a favorite of mine since I was a very young child, as have the early films of Walt Disney. *Alice's Adventures in Wonderland* and *Through the Looking-Glass* were such delightful stories and I marveled at *Snow White* and *Bambi* in the movie theaters, so you can imagine what a thrill it was for me to play the role of Alice in Walt Disney's animated version of Carroll's classic tale.

Working with Walt and his talented team of artists and technicians was, I suppose, in many ways my own adventure into a different kind of Wonderland. From storyboard conferences and recording sessions to live-action reference work, there were so many unusual and extraordinary things for a ten-year-old to experience—and so many memorable characters to meet along the way, as well. Milt Kahl and Marc Davis (who were both so talented) teaching me the animation process; rolling around inside a giant plastic bottle; sharing tea with the marvelous Ed Wynn as the Mad Hatter; and of course, the one and only Walt Disney! It was a wonderful world of make-believe, magic, and hard work.

I learned so much throughout the years we were in production, and there are aspects of my experiences as Alice—and with Walt—that I still carry with me today. Alice's curiosity taught me the importance of holding a genuine inquisitiveness about the world around me. Her open-mindedness with the colorful inhabitants of Wonderland showed me the enjoyment of holding a sense of wonder with all of the colorful aspects of life. And I'm reminded of Alice's sense of adventure—a willingness to say yes to wherever the road takes you—because "it doesn't much matter which way you go," even if you "don't much care where."

To see so many of my *Alice* experiences and characters together again in this marvelous collection is a delight, and I'm certain you'll enjoy exploring these various trips to Wonderland. I'm so grateful for the many opportunities I've had and the people I've met on this adventure. To paraphrase Alice once again, it was "the silliest"—and most wonderful—"tea party I ever went to!"

— **Kathryn Beaumont**
as told to Mindy Johnson, September 2015

OPPOSITE: Alice falling down the rabbit hole concept from 1951's *Alice in Wonderland*. Artist: Mary Blair. Medium: Gouache.

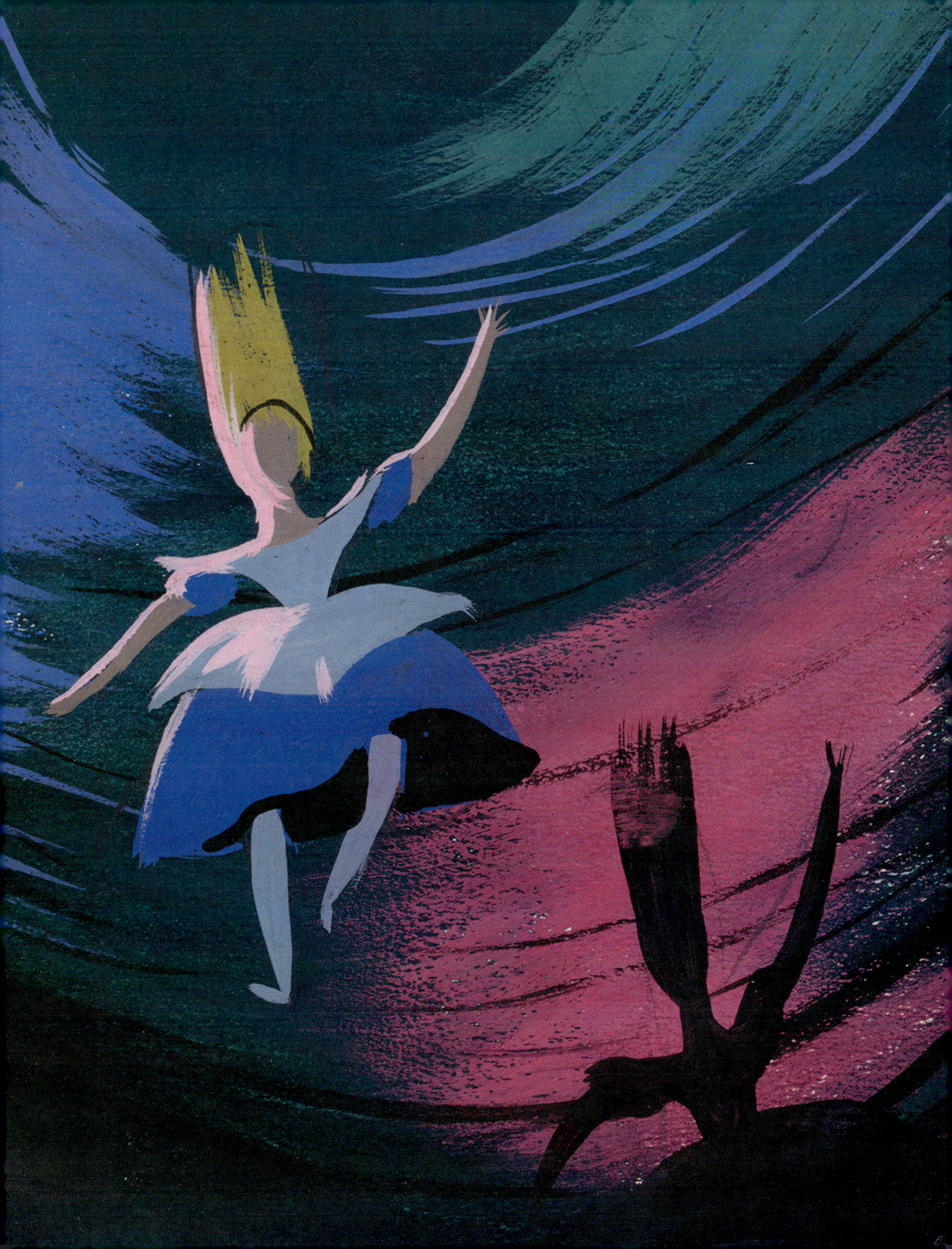

Introduction

"Begin at the beginning," the King said, very gravely,
"and go on till you come to the end. Then stop."

My grandmother lived near Oxford. We used to go there every Sunday afternoon for honey sandwiches and cups of very sweet, milky tea. As a child, I regularly visited Christ Church meadow and even on occasion punted down the very same river where a century before Lewis Carroll had first told young Alice Liddell his adventures featuring her namesake. Like many children growing up in England, Alice was a central feature of my childhood, as my parents read me the trippy tales of Cheshire Cats and impossible things while I, just like Alice, began to navigate my adventures through the curious, odd, and amusing world before me.

In many ways, Lewis Carroll seems to be at the heart of a surprising amount of what it means to be English. In both *Alice's Adventures in Wonderland* and *Through the Looking-Glass, and What Alice Found There*, Carroll brilliantly parodies, reflects, and passes judgment upon the steady stream of English anxiety about class, manners, language, and speech that has never really dissipated. It is social commentary at its subtlest. Moreover, the absurdist comedy that is central to much of his writing was the direct forerunner to the world of comedy in which I grew up, from Monty Python to *The Goon Show*, via *Beyond the Fringe*.

Through the Looking-Glass was published in 1871, six years after *Alice's Adventures in Wonderland*. Lewis Carroll imagined a still young Alice reentering the world he created where she again met the Mad Hatter, along with the kings and queens of a chessboard and a whole host of new characters, including Tweedledum and Tweedledee, plus Humpty Dumpty. It also includes the poem "Jabberwocky." Both the 1951 animated feature and the 2010 live-action film happily merged stories from both books.

Through the Looking-Glass has a dreamlike structure in which events fold into one another; it is deliberately episodic, and whilst the imagery is compelling, ultimately the book becomes more of an allegorical device—the journey of Alice over eight chapters (as in eight moves on a chessboard) from pawn to queen.

Linda Woolverton, in her brilliant script for *Alice Through the Looking Glass*, was able to take elements from the book that felt unique and important to the context and setting of the film, but she was also interested in taking the characters as Tim Burton had envisioned them and creating a new story for them within the framework of the *Looking-Glass* world. And this excited me—particularly the idea of Alice as a young woman. In other words, the woman she grew up to be . . .

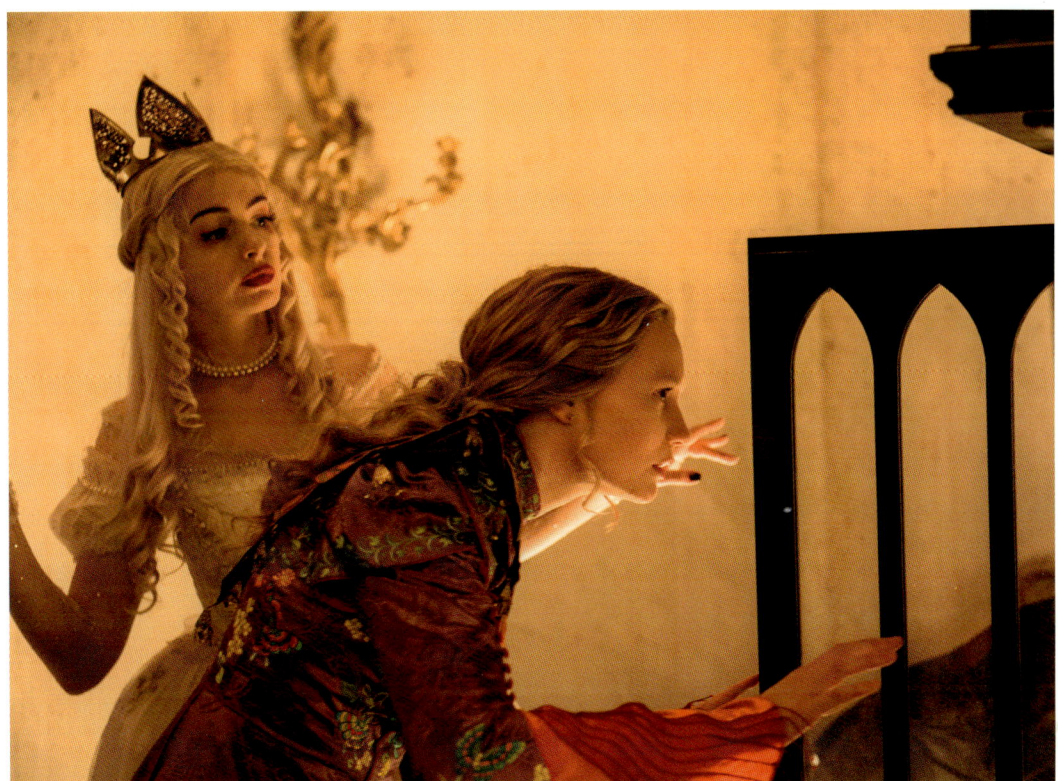

The White Queen (Anne Hathaway) leads Alice (Mia Wasikowska) to the Grandfather Clock where she can find Time, one mile past the pendulum.

The original Alice, Alice Liddell, was born in 1852, just six years before Emmeline Pankhurst, the founder of the suffragette movement. This was a generation of Victorian woman who set out to change the world. Carroll's Alice clearly represents them.

Throughout both books, Carroll's Alice firmly believes in herself and her voice. She seeks and expects to be treated equally to any of the men, and it is difficult to overstate Alice's truly radical nature when seen in the context of Victorian England. She has her own ideas, her own agency, and a way of refusing to be defined by the narrow assumptions of others. In Alice, Carroll saw the future.

Alice represents a new generation of women fighting for equal rights by going down a rabbit hole into a very different world where traditional gender roles have been turned upside down, and thank goodness she does: the world is so much better for it. It is why, when in doubt or faced with a particularly challenging conundrum, I sometimes like to ask myself, "What would Alice do?"

I would like to thank all those who helped me make this film, and Walt Disney Pictures in particular, for allowing me to answer that question.

— **James Bobin**
Los Angeles, October 2015

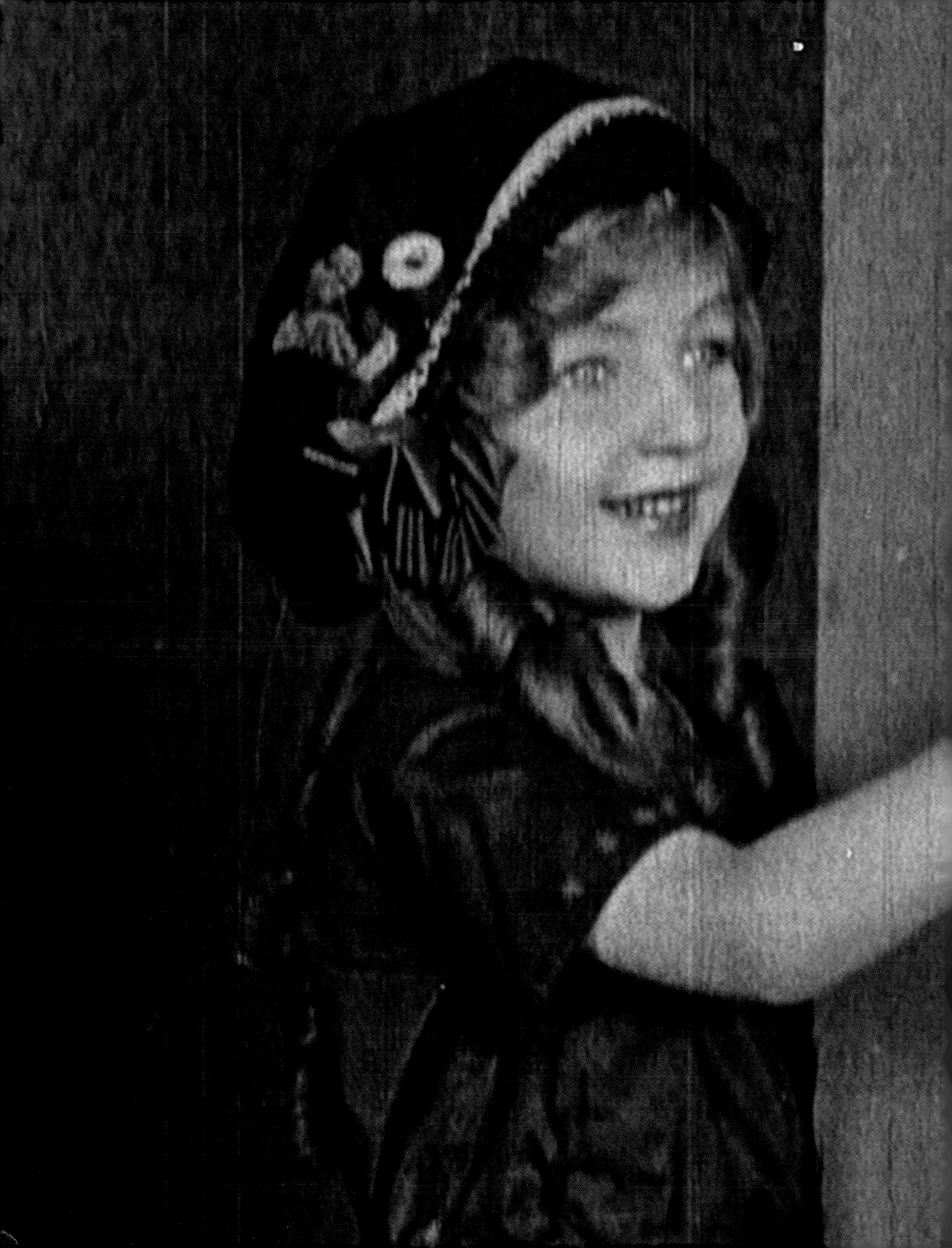

1
Start at the Beginning

The Alice Comedies

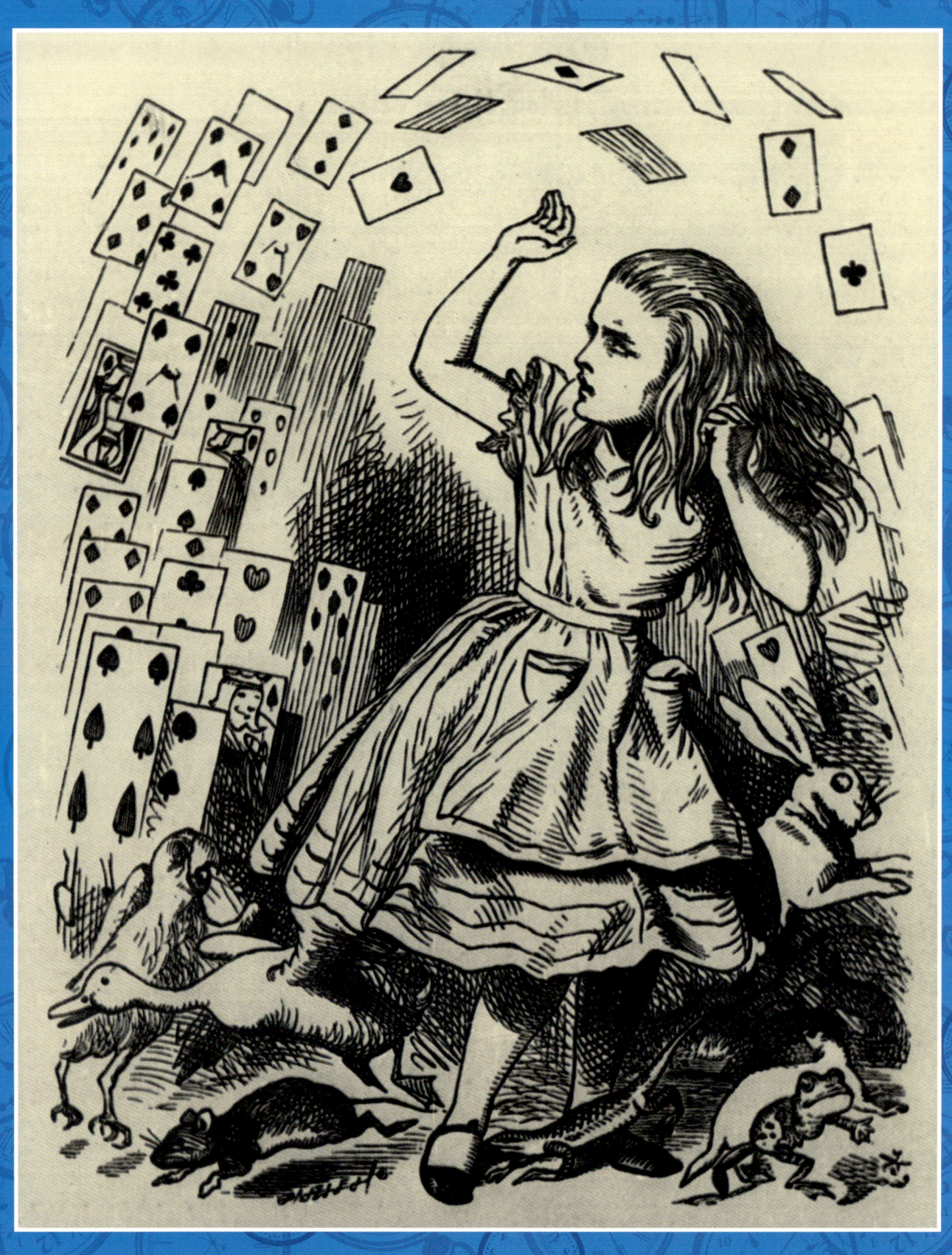

WALTER ELIAS

Disney, better known as Walt, was like so many children of his generation, and countless since. He was enchanted by Lewis Carroll's book *Alice's Adventures in Wonderland* and its sequel, *Through the Looking-Glass* (two children's classics now more commonly presented as one under the combined title of *Alice in Wonderland*).

"No story in English literature has intrigued me more," Walt revealed later in life. "It fascinated me the first time I read it as a schoolboy, and as soon as I possibly could, after I started making animated cartoons, I acquired the film rights to it."

First published in April 1865, *Alice's Adventures in Wonderland* remains one of the greatest pieces of children's literature. The telling of the story of a bored seven-year-old who tumbles down a rabbit hole and into a dreamland populated by strange creatures—among them a nutty Hatter, a tardy Rabbit, a mischievous Cheshire Cat, a hookah-smoking blue Caterpillar, and an irate Queen of Hearts—has become part of all our subconscious. Its characters, situations, and phrases are forever burrowed into our collective psyche. And in the century and a half since its release, Carroll's work has continued to amaze and entertain, as well as dazzle and delight; its influence and legacy still reach far beyond its

TOP: Book cover of Lewis Carroll's *Alice's Adventures in Wonderland*, 1898 edition

ABOVE: Portrait of Walt taken in Kansas City, Missouri, circa 1921

LEFT AND OPPOSITE: Oversized Alice in the White Rabbit's home and Alice facing a swarm of cards, from Lewis Carroll's *Alice's Adventures in Wonderland*, 1865 edition. Artist: Sir John Tenniel. Medium: Preliminary pencil drawing, inked, and transferred to woodblock engraving.

Walt Disney's Alice in Wonderland

pages, into all forms of popular culture, from films to fashion, video games to theme park rides, and to so much more.

"It's still fresh," says Johnny Depp, who played Carroll's iconic Mad Hatter in Tim Burton's 2010 adaptation, *Alice in Wonderland*, and reprises the role in its cinematic sequel, *Alice Through the Looking Glass* (2016). "If it were written yesterday, and released on shelves today, people would still be as amazed by it as they were then. It's a monumental achievement."

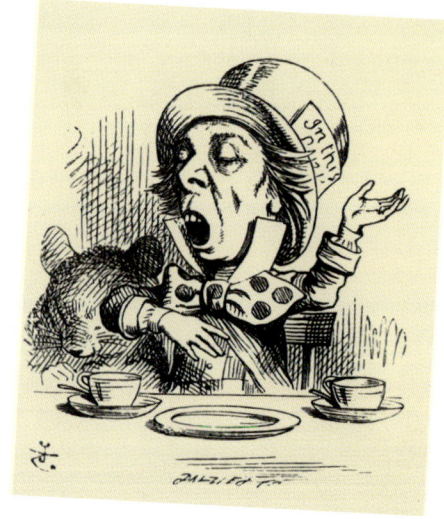

Lewis Carroll was, in fact, the nom de plume of the Reverend Charles Lutwidge Dodgson, professor of mathematics at Christ Church College, of Oxford University, in England, plus a keen amateur photographer, and a wellspring of stories, poetry, and even jokes and riddles. Legend has it that the author conceived the *Wonderland* story one sunny July afternoon in 1862 when he, together with the Reverend Robinson Duckworth, rowed the three young daughters of Henry George Liddell, vice-chancellor of Oxford and dean of Christ Church, along the River Thames, from Folly Bridge (near Oxford) to the village of Godstow, a few miles to the northwest.

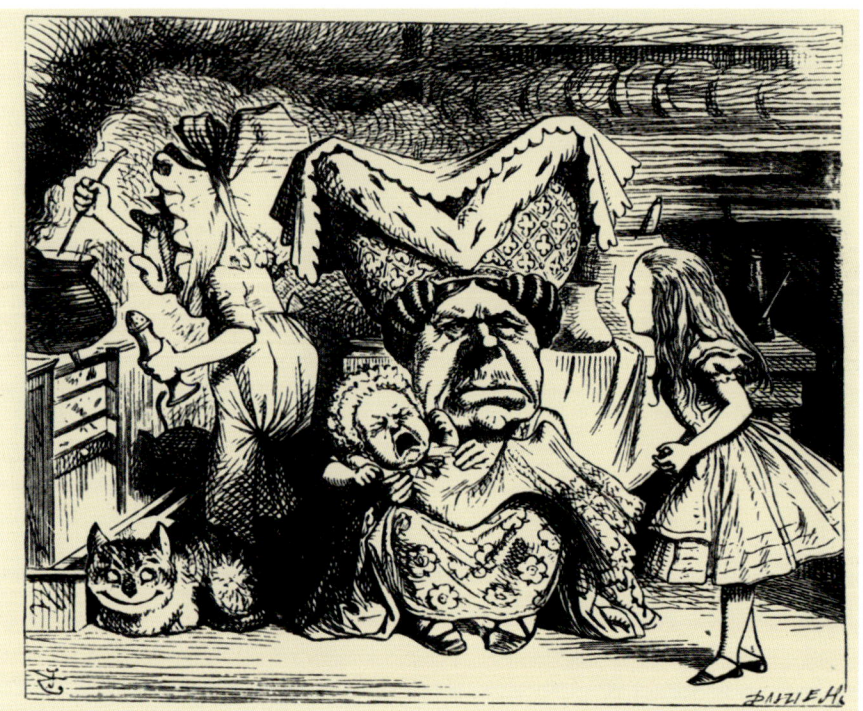

THIS PAGE: Illustrations from Lewis Carroll's *Alice's Adventures in Wonderland*, 1865 edition. Artist: Sir John Tenniel. Medium: Preliminary pencil drawing, inked, and transferred to woodblock engraving.

OPPOSITE: *Alice* author Lewis Carroll, aka Charles Lutwidge Dodgson

16

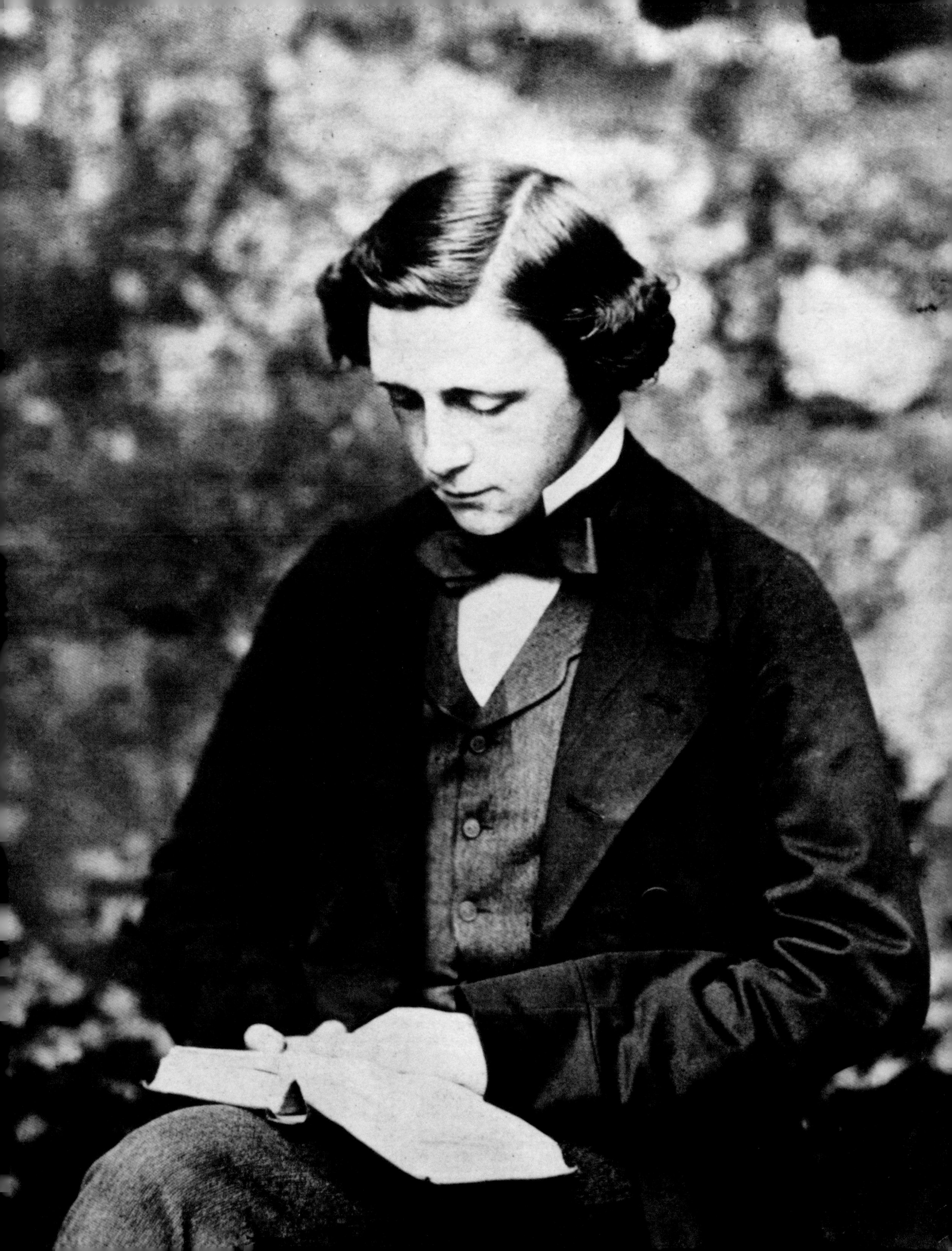

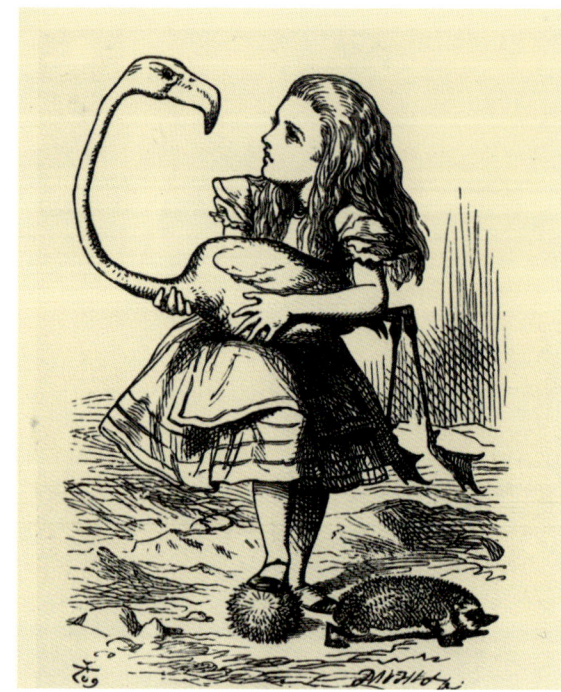

ABOVE: Alice with a flamingo croquet mallet from Lewis Carroll's *Alice's Adventures in Wonderland*, 1865 edition. Artist: Sir John Tenniel. Medium: Preliminary pencil drawing, inked, and transferred to woodblock engraving.

RIGHT: Alice Liddell, in a photo taken by Lewis Carroll

BELOW: Sir John Tenniel

As they moored their boat for a picnic, according to lore, Dodgson began to spin a tale about a dream child called Alice and her adventures in a kaleidoscopic playground to keep the girls—Lorina, thirteen; Alice, ten; and Edith, eight—amused and entertained. Characters, seemingly, were culled from some of his earlier stories, and, effectively, made up by the author as he went on with the story.

In reality, the weather on that particular day—July 4, 1862—was cool and damp, according to official meteorological reports. And, in all likelihood, Dodgson's *Wonderland* tale was most probably the result of several boat trips rather than one. What's not in dispute, however, is that Alice Liddell was so taken by what she'd heard that she pestered Dodgson to write it down for her.

Dodgson was, himself, rather captivated with the young girl and happily obliged, and on November 26, 1864, he presented her with an eighteen-thousand-word handwritten manuscript entitled *Alice's Adventures Underground*, complete with his own hand-drawn illustrations. A year later, encouraged by novelist George MacDonald, who'd read the original manuscript to his children, Dodgson expanded the story to thirty-five thousand words, and as the now-retitled *Alice's Adventures in Wonderland*, it was published by Macmillan. In addition to nearly doubling the size, the new book came with forty illustrations by Sir John Tenniel, the great British political cartoonist whose scratchy, crosshatched black-and-white drawings would become the de facto look of the characters for decades to come.

Alice's Adventures in Wonderland was an almost-immediate sensation, receiving rave reviews and eventually selling out its first printing of two thousand copies. Children's literature would never be the same again. Subversive and surreal, comic and chaotic, Carroll's literary magical-mystery tour opened the door on the possibilities of the imagination and willed the reader to step through.

Filled with complex mathematics, heavy symbolism, and allusions to Carroll, his friends, and their life at Christ Church, it was a revelatory piece of fiction, a classic example of literary nonsense—one that arguably presented the first fictional journey into a fantastical land, but also told its story from a child's perspective. Published at a time when children's literature was worthy and moralizing—more designed to teach its readers

to be good, upstanding citizens than enlighten or entertain—*Alice* ran counter to that. Its protagonist was given the freedom to question the ways of the world and, in particular, the grotesque, often ineffectual adult figures she encounters in Wonderland.

Six years later Carroll followed *Alice's Adventures in Wonderland* with a sequel, *Through the Looking-Glass, and What Alice Found There*, inspired by his introduction to another Alice, Alice Raikes, in London in 1871. This book, which was again illustrated by Tenniel, proved to be even more popular than its predecessor, introducing Tweedledee and Tweedledum, talking flowers, the Red Queen, the White Knight, the Walrus and the Carpenter, and the poem "Jabberwocky" into the *Alice* canon.

Thanks to the books' success, Carroll became the leading children's author of his generation and, in 1886, oversaw a London-stage adaptation of them. The first film version, running just twelve minutes, was a silent film released in 1903; it was directed by Cecil M. Hepworth, and starred May Clark as Alice.

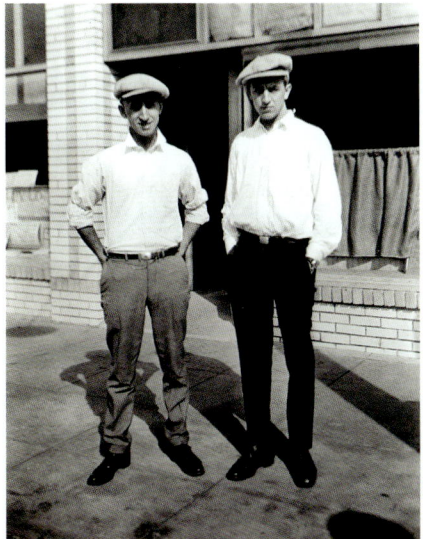

ABOVE: Book cover of Lewis Carroll's *Through the Looking-Glass*

RIGHT: Alice meets the Tweedles in the same book. Artist: Sir John Tenniel. Medium: Preliminary pencil drawing, inked, and transferred to woodblock engraving.

BOTTOM: Roy (left) and Walt in front of their Disney Brothers Cartoon Studio on Kingswell Avenue in Los Angeles' Los Feliz district circa 1924

IT'S not known whether the young Walt Disney ever saw Hepworth's silent movie, or others that followed, such as Edward Stanton Porter's 1910 *Alice's Adventures in Wonderland* and W. W. Young's 1915 adaptation. Born in Chicago in 1901, Walt lived in Kansas City, Missouri, from ages nine to fifteen.

A short time later, after a year working as a Red Cross ambulance driver in France following the end of World War I, he returned to the United States with aspirations of becoming an actor, artist, or cartoonist before eventually finding employment with Pesmen-Rubin Commercial Art Studio at Grays Advertising in Kansas City, where he drew ads for newspapers and movie theaters. It was here that Walt, now eighteen, met fellow artist Ubbe Iwwerks (later known as Ub Iwerks) with whom he would form, in 1920, a commercial arts business called Iwerks-Disney Studio. It was only open for a month, but it led Walt and Iwerks to join the Kansas City Film Ad Company, where they learned to animate, with the pair writing and directing ads.

Walt was hooked on what was then still a nascent medium. "The trick of making things move on film is what got me," he recalled later.

In 1921, Walt set up shop in his father's tiny garage and, with the help of his older brother Roy, began making experimental cartoons of his own. That fall, while still working at Film Ad, he started Kaycee Studios,

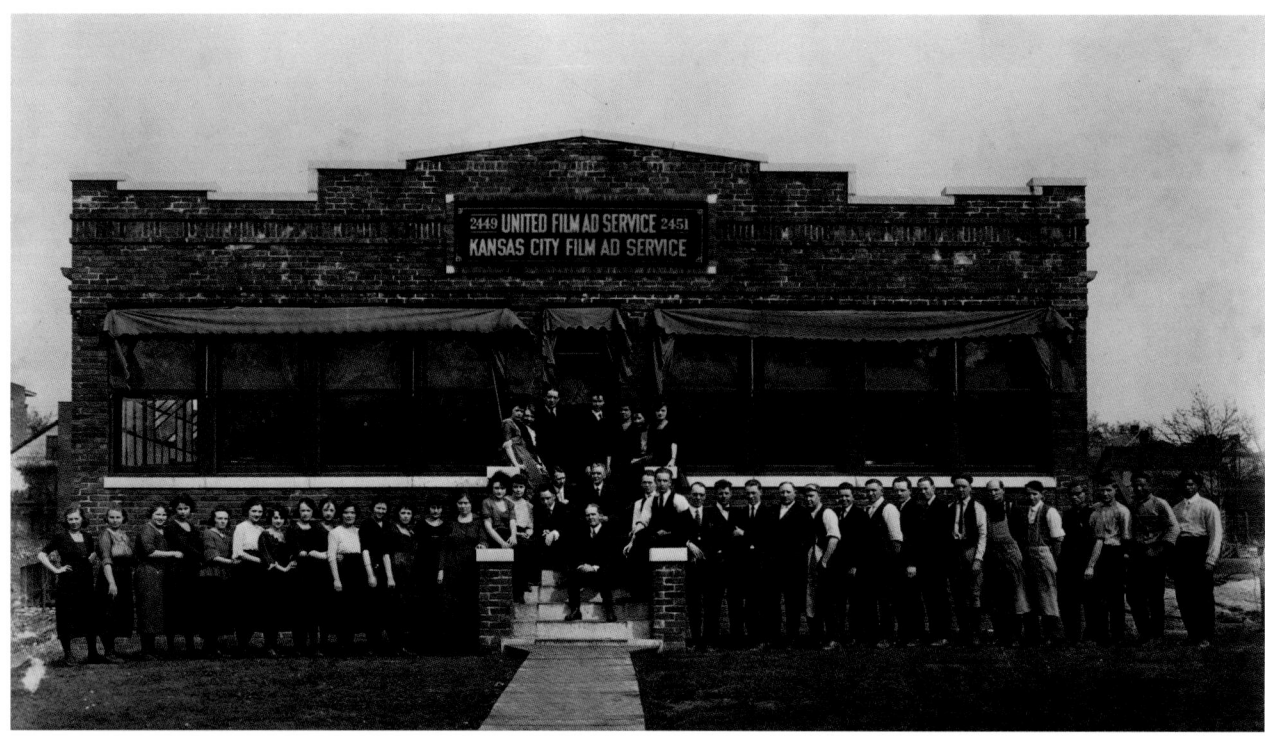

ABOVE: Walt among his coworkers in front of the Kansas City Film Ad building

BELOW: Title card from *Cinderella* (1922), the last of the six Laugh-O-gram fairy-tale cartoons that Walt developed in Kansas City, Missouri

producing a series of animated one-reelers, contemporary spins on traditional fairy tales. Included among them were *Red Riding Hood* and *The Four Musicians of Bremen*. The Kaycee venture lasted just a year before Walt decided to go into business as a producer of animated cartoon comedies and formed a new company, Laugh-O-gram Films, with a staff of ten, including Iwerks, who in November 1922 started as his chief animator.

Still, while only twenty years old, Walt animated, operated the camera, and continued the fairy-tales series with *Jack and the Beanstalk*, *Goldie Locks and the Three Bears*, and *Puss in Boots*. But Walt, not for the last time, began to overstretch himself, and Laugh-O-gram Films soon ran into financial trouble, particularly when a long-promised distribution deal failed to materialize. Walt moonlighted as a newsreel cameraman and baby photographer to keep the company afloat, but his efforts weren't enough: Laugh-O-gram was quickly heading toward bankruptcy.

By then, however, Walt had had an idea for a new cartoon series. With the talented Iwerks by his side, Walt proposed a series of shorts that would combine live-action with animation. While the idea itself wasn't new—animated characters interacting with the real world was familiar from Max and Dave Fleischer's cartoon series *Out of the Inkwell*—Walt's twist was that a real character would enter an animated world and intermingle with cartoon characters, specifically a girl called Alice, so named after Lewis Carroll's singular creation.

Alice's Cartoonland, as the test film was initially titled, would prove to be pivotal to not only Walt's future as an animation producer, but also the medium in general. To find his Alice, Walt remembered a young girl who'd appeared in an advertisement playing at the local theater, "eating," as he recalled, "this piece of Warneker's Bread with a lot of jam on it." With her blond ringlet curls and winning smile, the four-year-old Virginia Davis was deemed a miniature Mary Pickford. Walt approached her parents with an offer of 5 percent of the receipts for Davis to star in his short. Both sides signed the contract on April 13, 1923, with work beginning immediately despite the studio's financial concerns.

Alice's Wonderland, as the short would come to be known, ran for twelve and a half minutes, with the opening credits announcing PRODUCED BY A LAUGH-O-GRAM PROCESS and SCENARIO AND DIRECTION BY WALT DISNEY. The film began with Alice (played by Davis) arriving at the Laugh-O-gram Films animation studio. "I would like to watch you draw some funnies," she tells Walt who asks her to be seated at his drawing desk where he has already sketched a doghouse on a sheet of paper. Suddenly, a cartoon cat runs out, having gotten into a fight with the doghouse's canine occupant.

On a nearby drawing board, soon after, two cats dance to a feline band, while, at another drawing station, an animated cat and a dog engage in a boxing match, cheered on by Laugh-O-gram staffers Rudolph "Rudy" Ising, Hugh Harman, Iwerks, and two others. Retrospectively viewed as perhaps a sign of things to come, the studio's real-life cat is shown harassed by a cartoon mouse that's armed with a sword and has a pointy tail.

That night, at home, Alice dreams of an animated world that's populated by cartoon characters. In her dream, she arrives in Cartoonland by train—its "over the mountains" journey presaging the train sequence in *Dumbo*—where she's greeted by a cartoon welcoming committee, before riding an elephant in a parade through the city. It's a parade that also features giraffes, dogs, cats, turtles, ostriches, and pigs. Not long after, four lions escape from their cage, chasing Alice through the countryside, in and out of a tree, and down a rabbit hole in the most overt nod to Lewis Carroll, before sending her running over a cliff. Alice, like her literary counterpart, tumbles down and down, before being woken by her mom back in her bedroom.

Walt filmed Davis at Laugh-O-gram's studio and in her own bedroom with her Aunt Louise playing her mother. For the Cartoonland sequences, Davis was photographed against a white backdrop onto which the cartoon characters were later added; Walt animated these scenes mostly by himself. The result was primitive but wonderfully effective: moviegoers saw Davis's bubbly persona balanced by the crude but fun cartoon characters and simplistic animation.

PAGES 21–24: Twenty-one final frames from 1923's *Alice's Wonderland* starring Virginia Davis as Alice

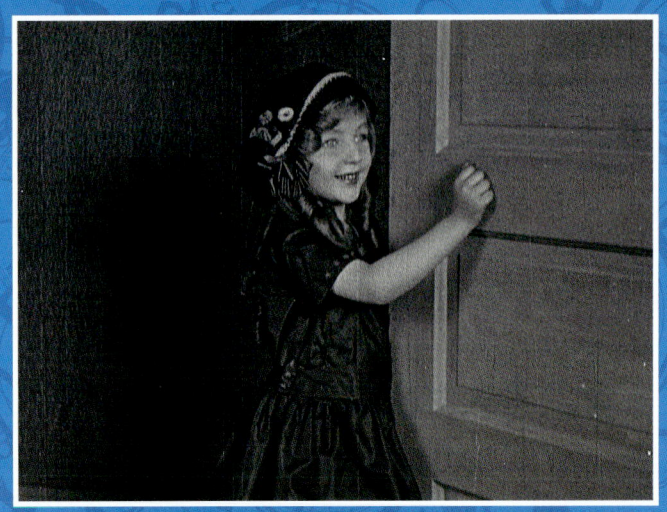

"I would like to watch you draw some funnies."

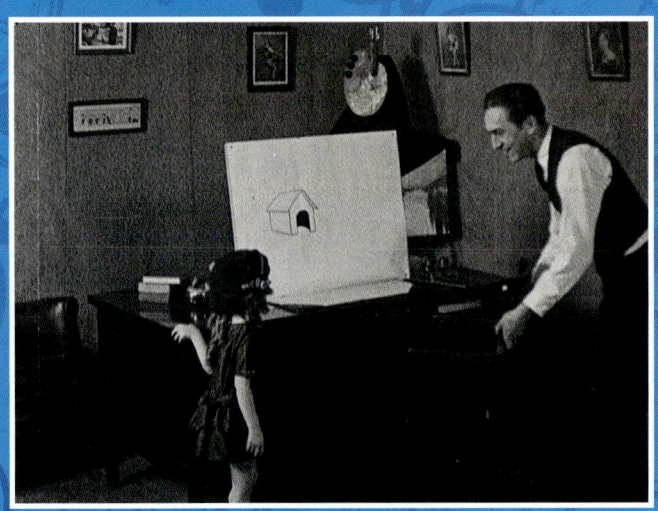

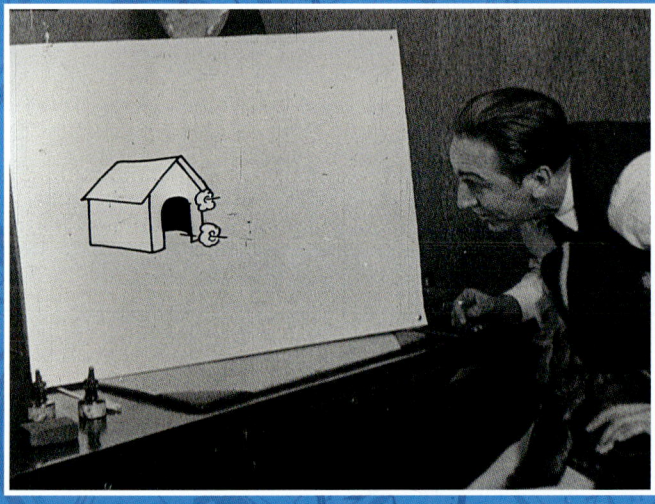

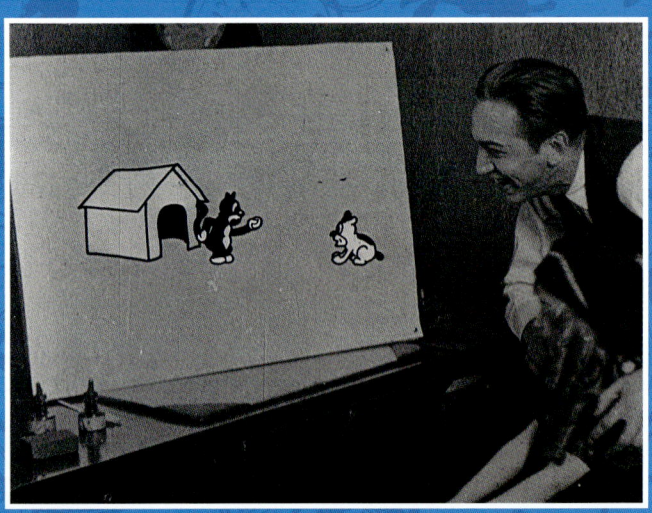

What Alice saw would make any little girl's heart flutter --- so that night when the sandman came-

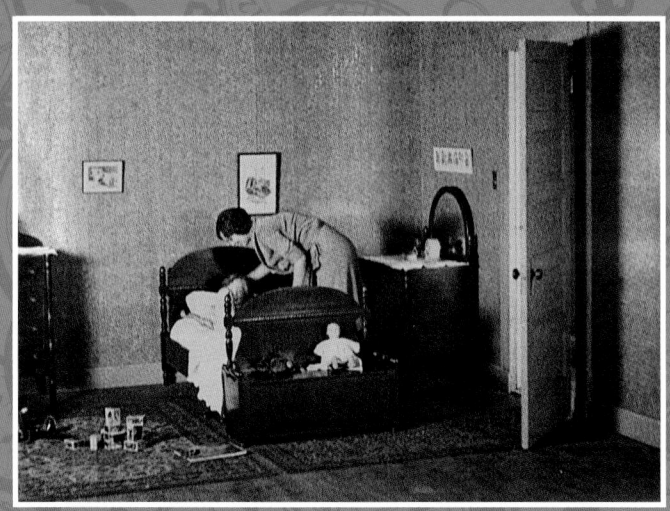
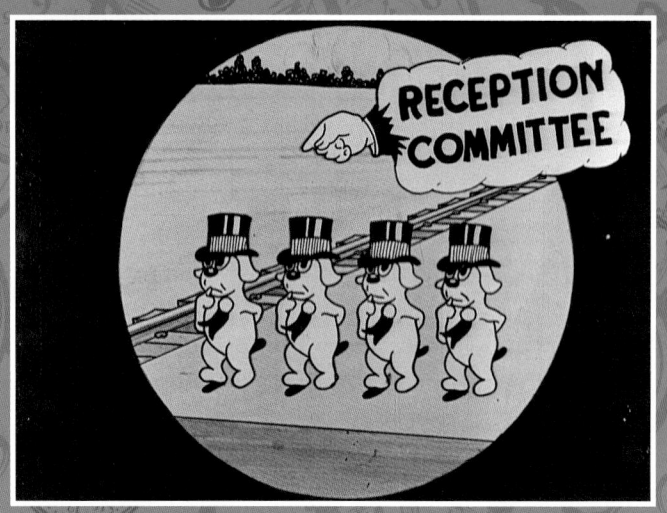
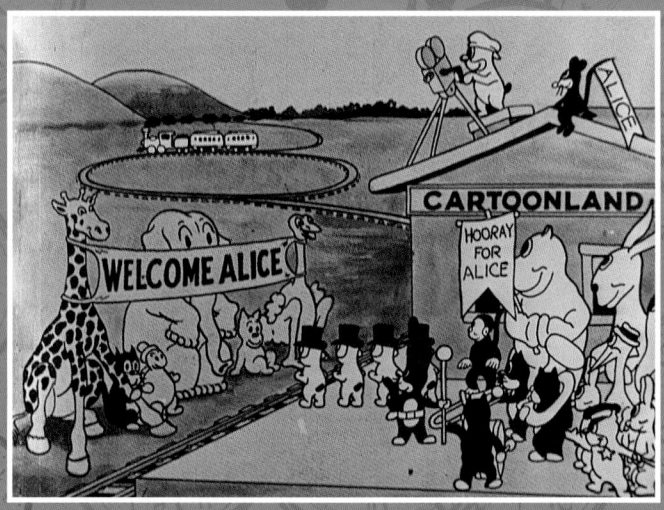

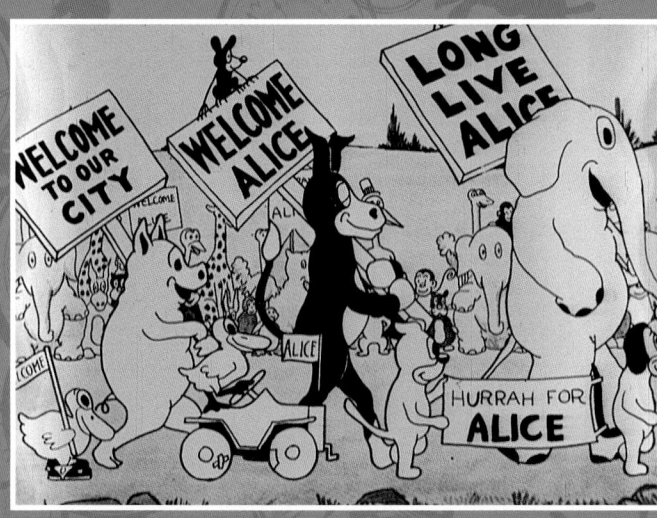
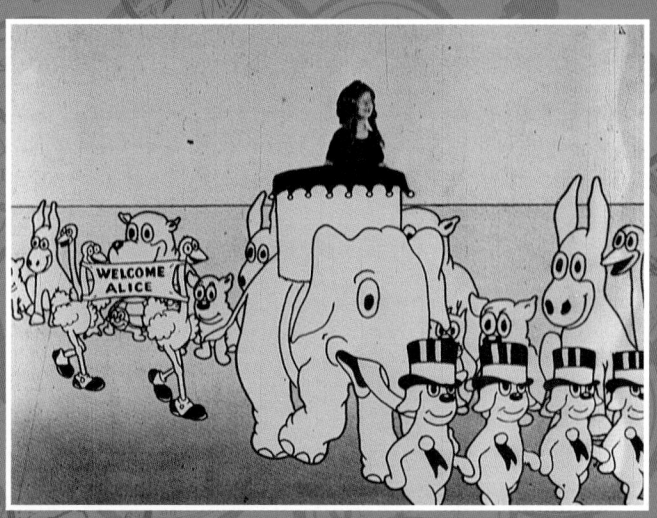

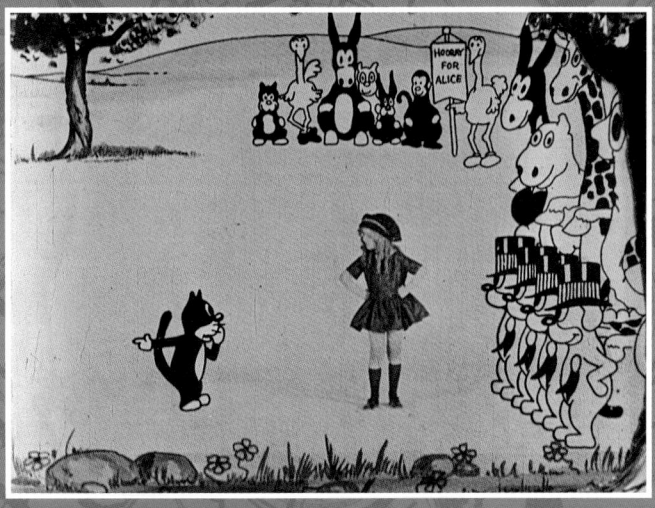
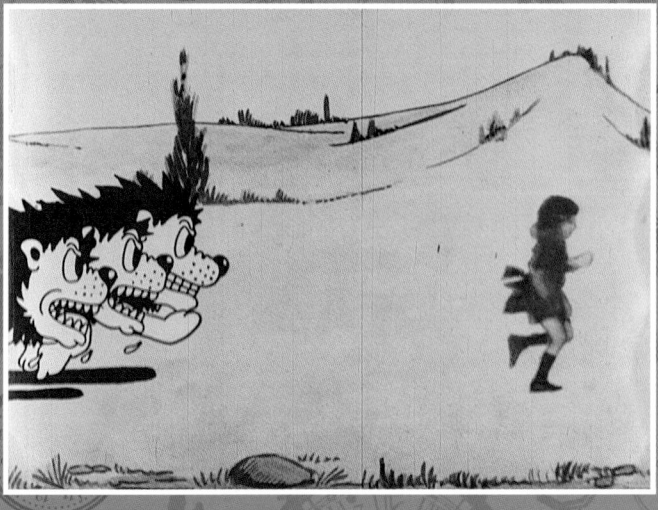
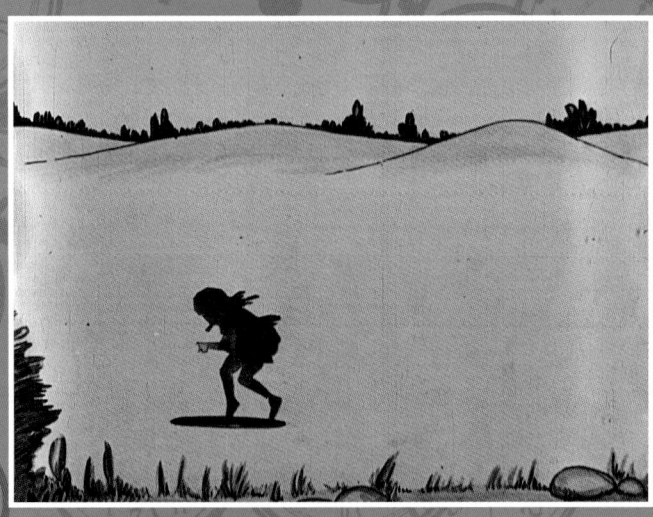
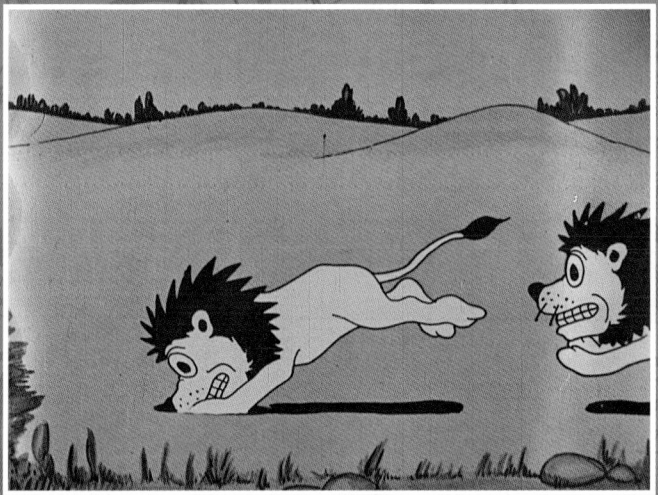
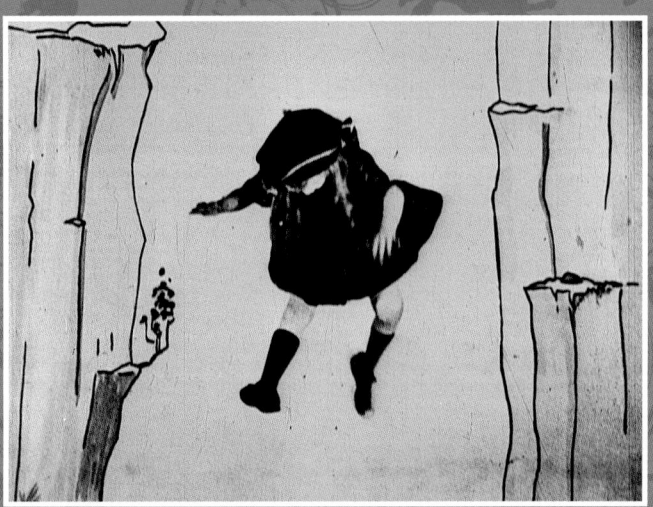

"Alice, Alice --- wake up!"

In May 1923, several months before the film was completed, Walt fired off letters to all potential distributors, keen to secure a deal for *Alice* which, he hoped, would turn around the company's fortunes. "We have just discovered something new and clever in animated cartoons," he wrote to New York-based film distributor Margaret J. Winkler. Walt then went on to describe his proposed series and promised to send her a print upon completion, continuing: "It is a new idea that will appeal to all classes and is bound to be a winner, because it is a clever combination of live characters and cartoons, not like *Out of the Inkwell*, but of an entirely different nature, using a cast of live child actors who carry on their action on cartoon scenes with cartoon characters."

Winkler, or Peggy as she was better known, was the first woman to produce and distribute animation in the United States and was the distributor of Pat Sullivan's Felix the Cat cartoons and the Fleischer brothers' *Out of the Inkwell* series; her releasing *Alice* would, Walt reasoned, guarantee its success.

On receiving Walt's letter, Winkler dispatched a swift, enthusiastic reply, writing, "If it is what you say, I shall be interested in contracting for a series of them." Walt took heart in Winkler's interest and, despite his and the company's worsening financial position—he'd been kicked out of his apartment and had taken to sleeping at the studio—pushed on to complete *Alice's Wonderland*.

By July, however, Laugh-O-gram Films was on the brink of collapse, unable to pay its debts, leaving Walt unable to capitalize on Winkler's interest. (She had written again in June asking when *Alice* would be ready.) The future appeared bleak and Walt, according to Ising, was mulling a move to New York, then the center of the animation industry, to work on Felix the Cat. When interviewed later—and in reflection, Walt suggested he was even thinking of quitting animation altogether. "I finally came to a great conclusion; I had missed the boat. I had got in the [animated field] too late. Film cartooning had been going on for all of six or seven years."

But when Walt shared his feelings with older brother Roy, who was undergoing treatment for tuberculosis at the Veterans Bureau hospital in the Sawtelle section of Los Angeles, his older brother wrote back, suggesting he move out to California instead. Not only did their Uncle Robert and his wife live there, giving Walt a place to stay, but, as Roy proposed, they could join forces to produce movies.

To pay for the trip west, Walt spent the next fortnight working as a freelance news photographer, as well as making baby films for Kansas City locals. That money, plus what he earned from doing work for a Kansas City doctor, provided enough to buy a first-class ticket to Los

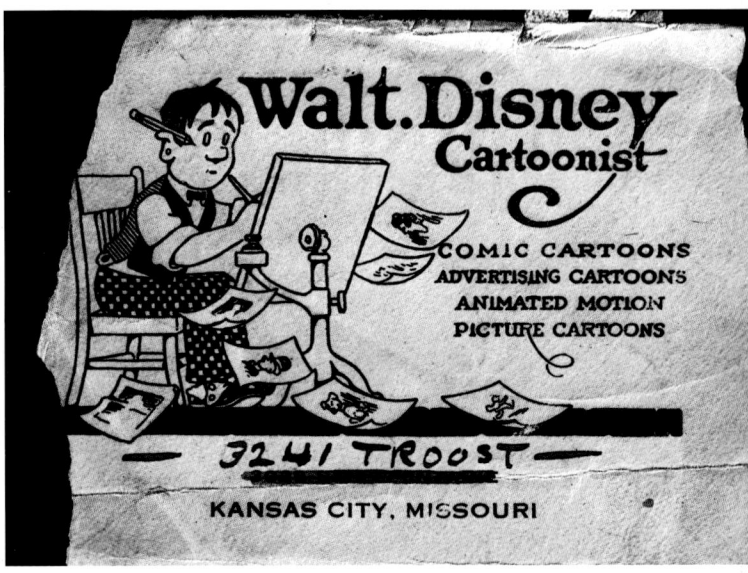

ABOVE: Walt's Kansas City, Missouri, stationery

Angeles and a movie camera. Armed with $40 and a print of *Alice's Wonderland*, Walt convinced his company's creditors to allow him to use the print as a show reel and promotional tool.

𝒟ℐ𝒮𝒩ℰ𝒴 packed his pasteboard suitcase and headed to "Hollywood," where he moved in with his uncle Robert, who was residing at 4406 Kingswell Avenue, in the Los Feliz neighborhood (adjacent to Hollywood).

It was, then, the golden age of silent Hollywood, the era of Charlie Chaplin and Mack Sennett, and of Greta Garbo and Cecil B. DeMille; Walt arrived in Los Angeles determined to make it as a motion-picture director. "I'm fed up with cartoons," he said. "My only hope lay in live-action movies."

Using his Kansas City press credentials, Walt spent a week doggedly knocking on any door, visiting studio lots, and watching movies being shot. According to Timothy S. Susanin's *Walt Before Mickey: Disney's Early Years, 1919–1928*, he even found work as an extra on the film *The Light That Failed*. There were, however, no offers to direct, nor did he find any takers for *Alice's Wonderland*, his one true calling card. It was hardly surprising. The animation industry was based in New York and there were no studios in California making cartoons. "Things looked pretty black. I was flat broke," said Walt who had to borrow money from Roy to pay for his rent. "I couldn't get a job."

In the end, Walt had only one choice available to him. "I went into business for myself," he recounted. With Roy's continued encouragement and financial help—the older brother received $85 a month from the government as a veteran—Walt returned to the drawing board, setting up in their uncle's one-car garage. He began by writing to Winkler once again, informing her he had moved from Kansas City to Los Angeles and had formed a new company called, fittingly, Disney Brothers Cartoon Studio. Disney noted that he would be producing a series of cartoons combining live actors, much like the one he'd previously created and discussed in their earlier correspondence. (He neglected to mention Laugh-O-gram's recent financial troubles.)

"The making of these new cartoons necessitates being located in a production center that I may engage trained talent for my casts and be within reach of the right facilities for producing . . ." Disney said. "In the past, all cartoons combining live actors have been produced in an amateur manner with cartoonists doing the acting, photographing, etc. It is my intention to employ only trained and experienced people for my

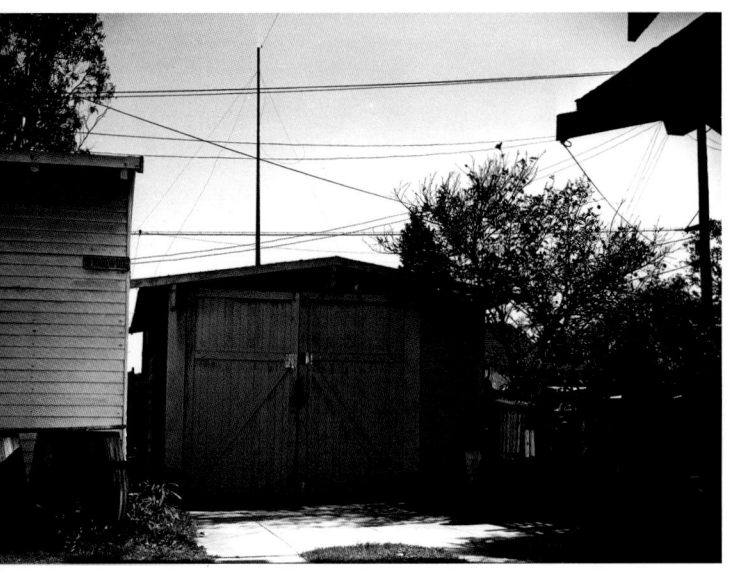

ABOVE: The garage, circa 1925, on Kingswell Avenue in Los Angeles' Los Feliz district, belonging to Walt's uncle Robert; it's where Walt began his Hollywood career.

casts and staff that I may inject quality humor, photography, and detail into these comedies."

Fortunately for the twenty-one-year-old Walt, Winkler was, at the time, involved in a contract wrangle with Sullivan over Felix the Cat and on the lookout for something new to distribute, should negotiations fail. Having finally seen a copy of *Alice's Wonderland* via Walt's New York representative, Winkler wired him to say she liked it, but had some reservations. "Believe series can be put over, but photography of Alice should show more detail and be steadier," she wrote, offering a contract for six films, with an option for six more. The fee was $1,500 per negative for the first six, rising to $1,800 for the second six, with the first to be delivered on December 15, 1923. Walt rushed to see Roy, who was still in the hospital, waking him with the news. "We're in, it's a deal," Walt's daughter Diane Disney Miller revealed in *The Story of Walt Disney*, as told to Pete Martin.

RIGHT: A young Roy Disney

BELOW: Walt, circa 1923, shortly after arriving in Los Angeles

After a moment's thought, Roy was on board. "Let's go," he said.

For Walt, the news was a double edge (cartoon) sword. Finally, he had a major distributor for his material, but he had no staff besides Roy, who discharged himself from the hospital to go into business with his brother. But there were soon other—even more—pressing matters. As part of the deal, Winkler insisted Virginia Davis reprise her role as Alice, and so Walt needed to convince the Davis family to relocate to California so their daughter could star in the proposed series. Walt wrote to her parents initially offering $100 per month for a twelve-month contract. Payment would then rise to $200 per month, with the option of a further increase to $250 per month. "It would be a big opportunity," he stated, "an opportunity that is hard to get on account of the great number of mothers that want to place their children in the movies."

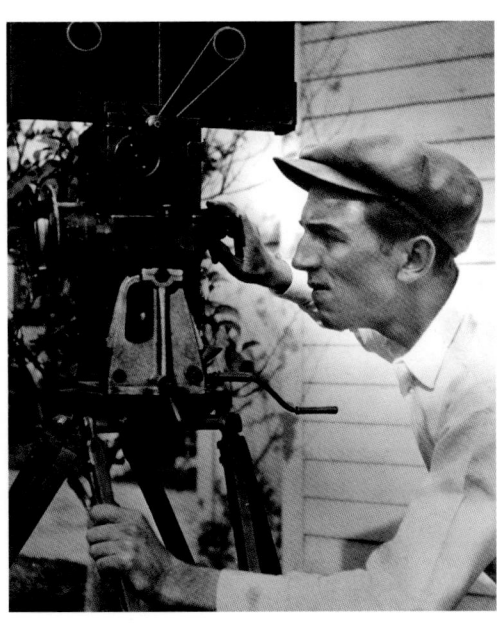

A week later they said yes to the move. Davis had had double pneumonia when she was younger, and her family was keen to relocate to a warmer climate. "My mother talked it over with my dad and they accepted the challenge," recalled Davis in 1998. The Davises—Jeff, a traveling furniture salesman; his wife, Margaret; and Virginia—arrived in Hollywood by train soon after.

To fund this latest venture, Walt and Roy required investment, but when they asked their uncle to loan them $500, Robert turned them down because, as Diane recalled in her book, he felt, "Walter doesn't pay his debts." In the end, however, Robert provided the money, and the

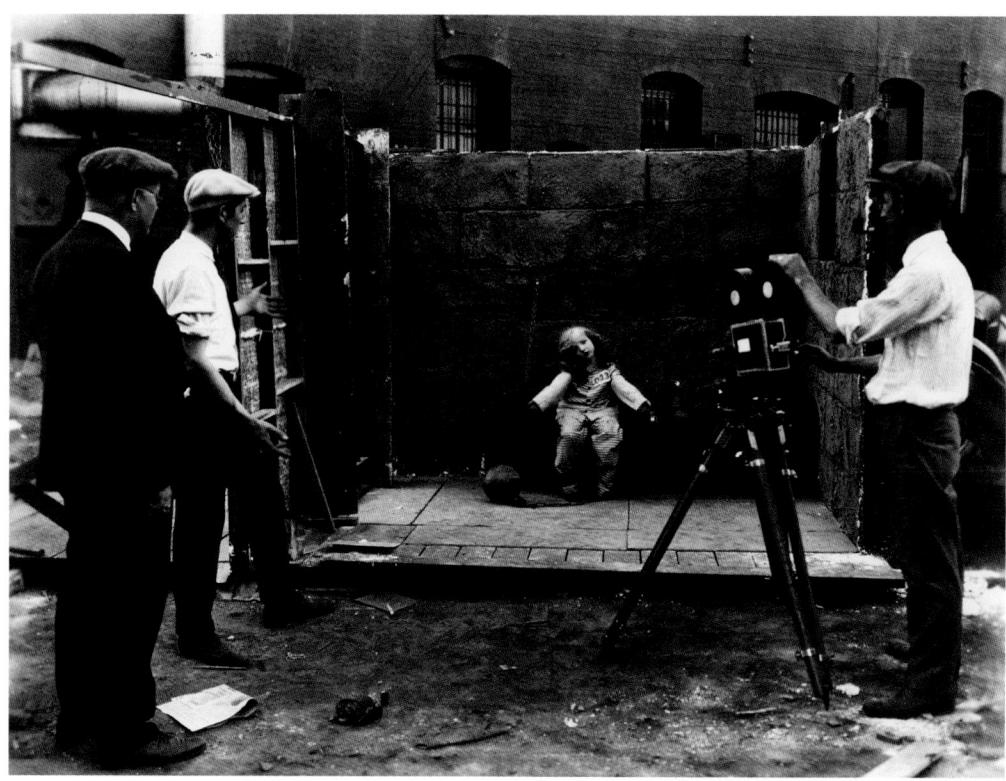

ABOVE: Roy films Virginia Davis, wearing a chain ball for 1925's *Alice the Jail Bird*, an Alice Comedy, while Walt directs.

OPPOSITE: Poster for 1924's *Alice's Day at Sea*, an Alice Comedy

"It is my intention to employ only trained and experienced people for my casts and staff that I may inject quality humor, photography, and detail into these comedies."

— WALT DISNEY

brothers rented a small space at the rear of a real estate office at 4651 Kingswell Avenue, several blocks west of their uncle's house.

With Roy operating as business manager, Walt was off and running, the fledgling studio starting production on *Alice's Day at Sea* even before the Davis family arrived in California. But while the animation on *Alice's Wonderland* had been handled by several artists in Kansas City, Walt was, due to budgetary constraints, now working on his own. Consequently, he wrote, designed, and animated *Alice's Day at Sea* single-handedly, as well as directed the live-action scenes, with Roy, who knew little about photography, doubling as cameraman for both the animation and live-action sequences. (Roy would subsequently be replaced on live-action duties by cameraman Henry Forbes and on animation by Mike Marcus.)

Alice's Day at Sea, which cost $750 to produce, making Walt and Roy an immediate profit, begins with a live-action opening in which Alice's pet dog drives her to the seaside. Once there, Alice winds up at the bottom of an animated ocean where she dances to an underwater band, is swallowed whole by a giant fish, and battles a six-tentacled octopus before waking in a (real) boat tangled in a fishing net.

When *Alice's Day at Sea* arrived at Winkler's New York office in late December 1923, she wired Walt immediately asking him to ship her all the raw footage. "All our films are recut in New York," she wrote. "We believe [*Alice's Day at Sea*] can possibly be improved by re-editing [sic] here.... While *Alice's Day at Sea* is satisfactory, I think you will agree

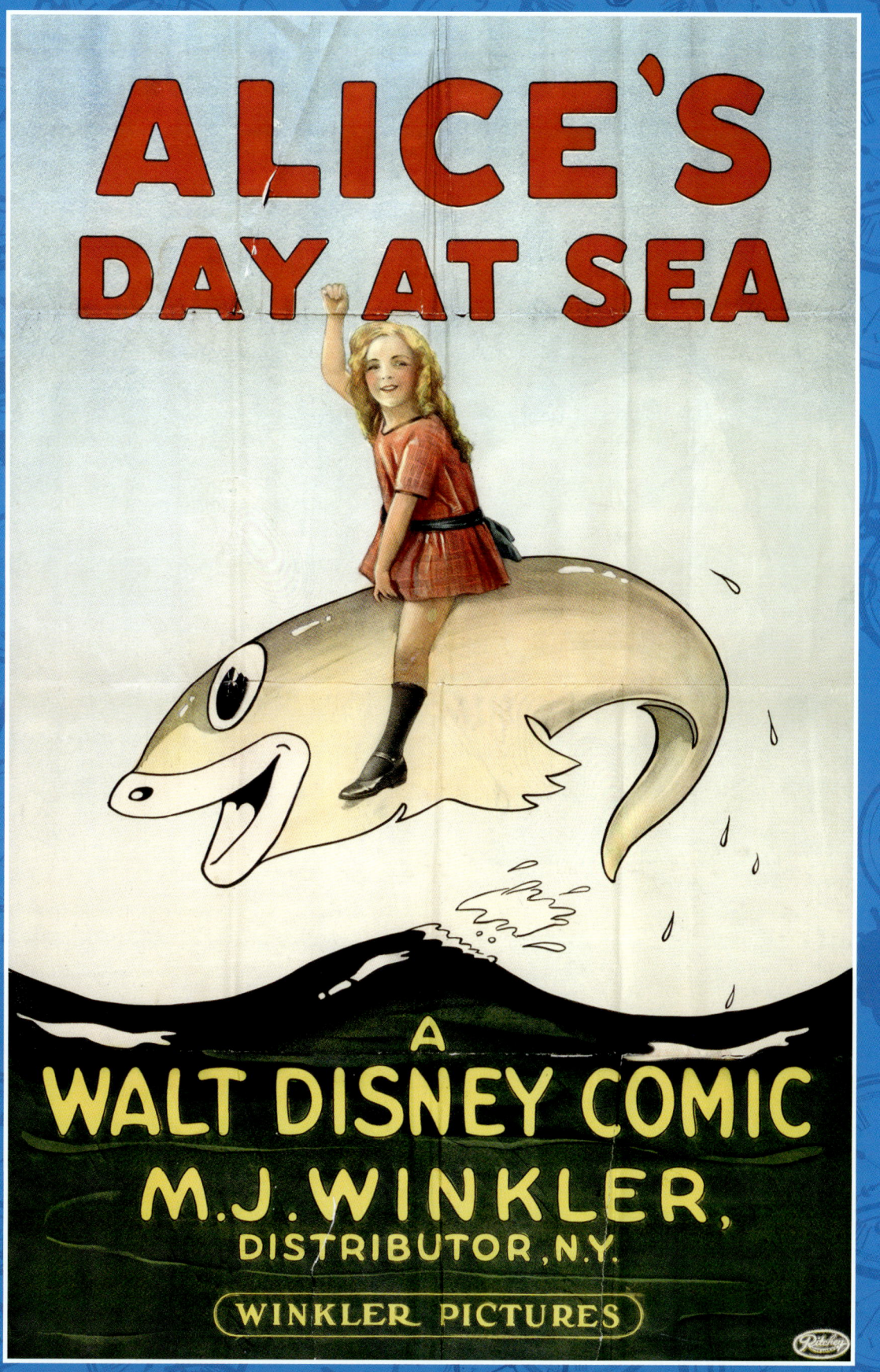

that there are some improvements to be made along general lines. . . . I am confident however that as we go along each subject will grow better."

Even after *Alice's Day at Sea* was reedited, Winkler wasn't totally happy and wrote to Walt again, advising him to "inject as much humor as you possibly can" into the subsequent films. "Humor is the first requisite of short subjects such as Felix, *Out of the Inkwell*, and Alice." But when the next film, *Alice Hunting in Africa*, arrived at the end of January, Winkler again felt it wasn't funny enough. "The comedy situations are still lacking. . . . Please again let me impress on you that future productions must be of a much higher standard than those we have already seen," she wrote.

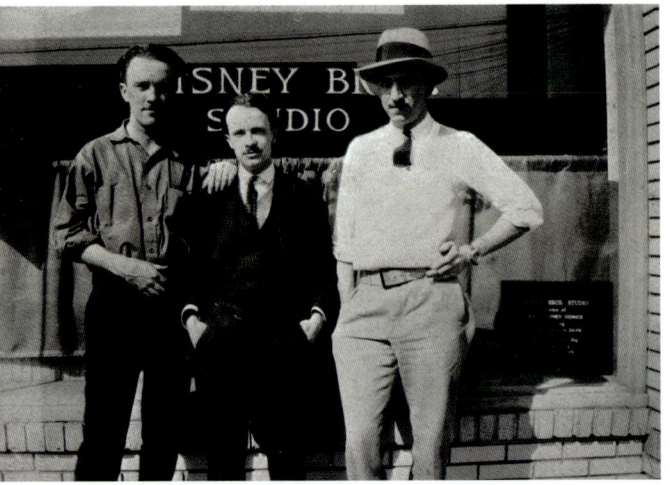

BELOW: Ub Iwerks, Rollin "Ham" Hamilton, and Walt pose outside the Disney Brothers Cartoon Studio, circa 1924.

BOTTOM: Poster for 1924's *Alice's Spooky Adventure*, an Alice Comedy

Yet Winkler clearly saw potential in Walt and the Alice films, sending him letters detailing the improvements in comedy, photography, and, most of all, animation she required. Her fiancé and later husband, Charles Mintz, a former Warner Brothers booking agent who would soon assume the company's day-to-day operations, was less impressed, arguing the films were poorly produced. Mintz lambasted their timing, gags, and combination of live action and animation. (For the series, Walt developed live-action scenarios to frame the animated sequences as a dream or a story told by Alice to essentially pad out the running time, thus saving himself time and money. But the bookends were a little on the long side.)

Winkler, however, stuck by Walt, continuing to encourage and tutor, and he, in turn, labored over every Alice short, spending more and more on each subsequent one, a strategy that quickly ate into the company's coffers, forcing Walt and Roy to beg friends and family for loans.

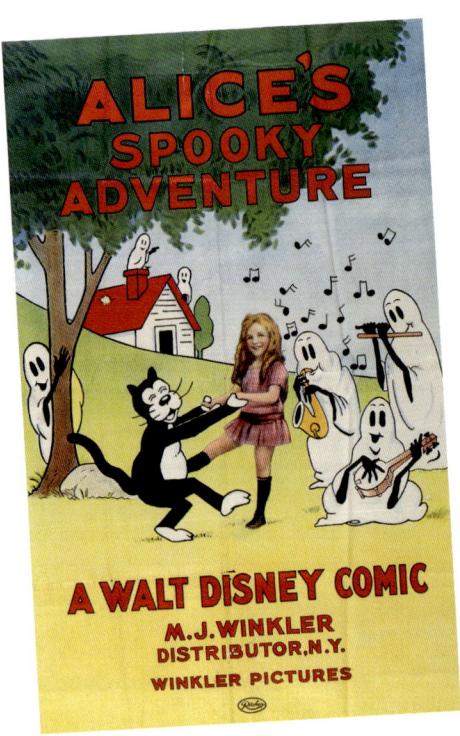

To keep up with Winkler's release schedule, more personnel and space were required, so Walt and Roy next moved the company to a vacant storefront studio next door at 4649 Kingswell Avenue. Among the new staff arrivals was Rollin C. "Ham" Hamilton, who joined in February 1924 to assist with animation and remained with Walt throughout the silent film years. Another was Lillian Bounds, who was hired to paint and clean the cels. She doubled as company secretary and, the following July, married Walt.

In March 1924, *Alice's Day at Sea* premiered in movie theaters, earning a glowing review from the *Motion Picture News*, which dubbed it, "A novel idea . . . very unique and entertaining enough to satisfy any sort of audience." Winkler considered the third film, *Alice's Spooky Adventure*, completed in late February, in which Alice enters an abandoned house to retrieve a lost baseball and dreams about a place called Spookyville, to be a marked improvement. So, reinforced by such positive responses, Walt moved ahead with *Alice's Wild West Show*, in which Alice and her

An Illustrated Journey Through Time

friends put on a cowboy act. But while Walt continued to listen to Winkler's advice, he soon was pushing back against some of her notions, telling her, "It is my desire to be a little different from the usual run of slapstick."

One Winkler suggestion, however, was to have a fundamental effect on the future direction of Walt's career. Still concerned about losing the rights to the Felix the Cat series, Winkler urged Walt to incorporate an animated cat whenever possible and advised, "Don't let him be afraid of doing ridiculous things." All of Walt's fairy-tale films to date, as well as *Alice's Wonderland*, had featured cartoon felines, while both *Alice's Spooky Adventure* and the fifth Alice comedy, *Alice's Fishy Story*, had employed a mischievous black cat as a sidekick. While this anthropomorphic cat, later named Julius, was, no doubt, meant to be a rival to both Felix and Krazy Kat (the character in a popular comic strip at the time), one can also see the beginnings of a certain animated mouse.

Other recurring animated creations included a canine cop who first appeared in *Alice the Peacemaker*, and a dachshund initially seen in *Alice Stage Struck*, who survived through the end of the series in 1927 and even beyond. *Alice Solves the Puzzle*, meanwhile, saw the introduction of a stock (animal) villain who steals Alice's crossword before chasing her into a lighthouse. Over the next seventy odd years, this character would undergo numerous physical changes (as well as those to his name), including a wooden leg, and emerge to become one of Walt's most popular supporting characters—Peg Leg Pete.

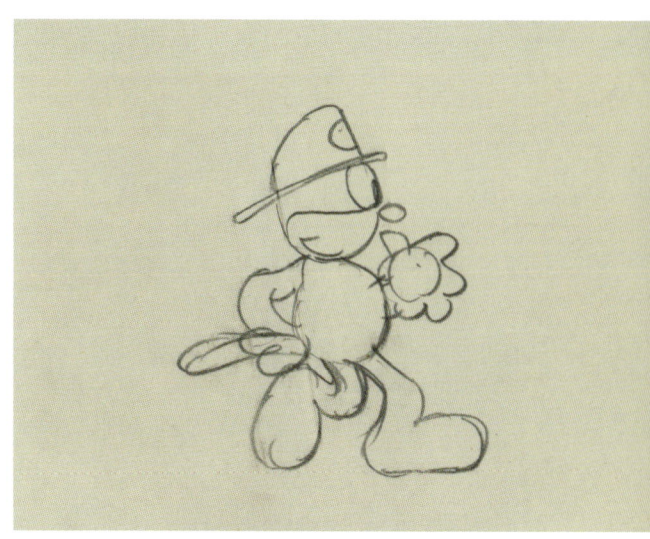

TOP: Julius the cat from 1926's *Alice the Fire Fighter*, an Alice Comedy. Artist: Disney Studio artist, cleanup animation. Medium: Graphite.

ABOVE: Julius on a title card from 1925's Alice Comedies series

ABOVE: First appearance of Pete from 1925's *Alice Solves the Puzzle*, an Alice Comedy

RIGHT: Pete's next incarnation (top), from 1927's *The Ocean Hop*, an Oswald the Lucky Rabbit cartoon, and Pete's more contemporary look (bottom), from 1940's *Mr. Mouse Takes a Trip*, a Mickey Mouse cartoon

31

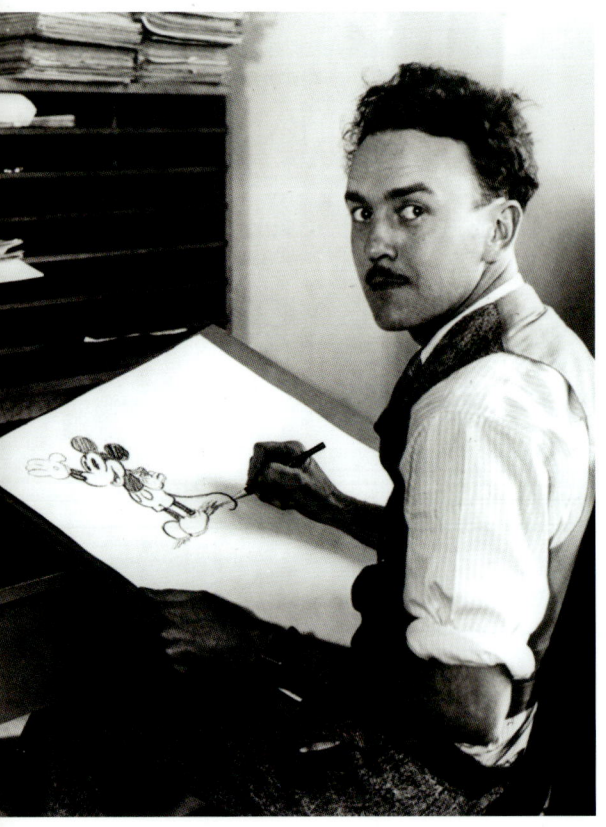

ABOVE: Ub Iwerks sketches Mickey Mouse, circa 1930.

BELOW: Poster for 1924's *Alice the Peacemaker*, an Alice Comedy

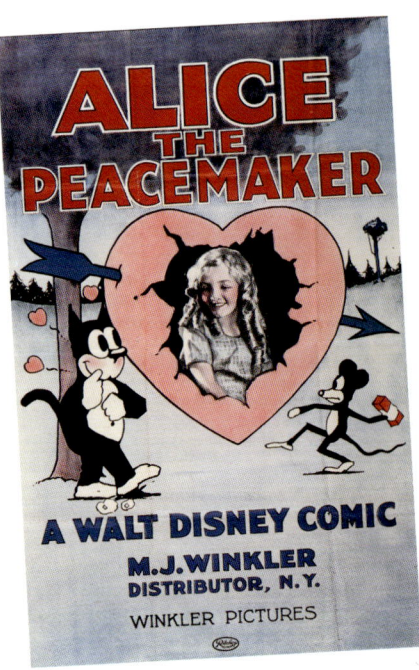

The sixth film in the series, *Alice and the Dog Catcher*, would be the last one Walt animated on himself. He starred in it, too, alongside Hamilton, as dog snatchers who are thwarted by Alice and her gang in the film's live-action bookends. Now twenty-two, and perhaps aware of his own artistic limitations, Walt made the decision to put down his drawing pencil to concentrate on writing, directing, and producing. "It reached a point I had so many working with me, and there was so much time and attention demanded that I had to drop the drawing end of it myself," he said later. "But I've never regretted it, because drawing was a means to an end with me."

Stung by Mintz's earlier, scathing comments regarding the quality of the series' animation, Walt wrote to Iwerks, who was still back in Kansas City, but now working for United Film Service, and offered him a job. Despite losing money in Walt's previous animated ventures, Iwerks agreed to join as an artist-cartoonist for Walt and Roy for a salary of $40 a month, arriving in Los Angeles in July 1924 with his mother, Laura May, the pair having driven the Cadillac the Davises had left behind in Kansas nearly a year earlier when they moved.

The first film Iwerks worked on was *Alice the Peacemaker*, in which Davis's character breaks up a fight between rival newsboys and an animated cat and dog do battle in the cartoon segment. (Despite having to take a $10 pay cut, Iwerks was, nevertheless, the studio's highest paid animator, earning even more than Walt.)

Following Iwerks's arrival, there was an immediate and marked improvement in the animation. By dropping the traditional use of model sheets as rough guides for animators, he injected more life into his drawings, producing characters "in constant motion as they try to outwit one another with increasingly ingenious maneuvers, their bodies and tails jumping, twirling, curlicue-ing in one continuous cycle of movement," wrote Leslie Iwerks (the animator's granddaughter, a documentary producer) and John Kenworthy in *The Hand Behind the Mouse*. It would mark the beginning of the smooth flowing "Disney-style" animation the studio would later become famous for.

To combine the live-action footage with the animation was a fairly complex process. Davis, a talented performer, would be filmed acting out her interactions with her invisible costars under Walt's direction in front of white tarpaulin that was draped over the back of a billboard and onto the ground. Because of the cost of film stock, Walt would shoot just one take before moving on, and, when required, would rope in various neighborhood children as extras, paying them fifty cents a day. The live-action footage would be placed inside a camera especially adapted to serve as a crude projection device, with the film projected frame by frame onto an animator's table where that person would then trace the outline of Alice onto a sheet of paper.

As the animation improved, so, too, did the storytelling and humor. "We have endeavored to have nothing but gags, and the whole story is one gag after another," Walt told Mintz as the partnership between the two seemingly grew—with the Alice Comedies introducing a number of visual gags and ideas that Walt would rework and follow in later Disney films. By the time of *Alice Cans the Cannibals*, Iwerks's fifth short since moving from Kansas, the series was finally taking off: "Each of these Walt Disney cartoons appears more imaginative and clever than the preceding," wrote a reviewer in the *Moving Picture World*, "and this one is a corker."

On the surface, things appeared to be going well for Walt. That October, Thurston Harper joined to assist Iwerks and Hamilton; *Alice Gets in Dutch* (which had come out a few months before *Cannibals*) had played at a first-run Broadway theater with Warner Brothers's *This Woman*; and the *Los Angeles Times* had featured an article about him. But economic concerns still dogged the company, as Walt's focus on quality at all cost continued to put the studio at risk. "We need money," he wrote to Mintz. "We have been spending as much as you have been paying us for [the films] in order to improve and make them as good as possible."

Walt had begun to delay paying his staff and was forced to borrow more money when Winkler's once prompt checks started to arrive late, and the promised $1,500 per film fee was slashed to $900.

By now, Walt was eager to excise the live-action framing stories entirely and fully commit to animation and animated characters, claiming "animals afford a bigger opportunity for laughs than people." Despite resistance from Mintz, the live-action bookends began to disappear in the series' films by the end of 1924. (*Alice Stage Struck*, made in spring 1925, in which Alice and her gang stage a show, was the last to feature them.)

On December 31, 1924, Walt signed a contract for a second series of Alice Comedies that called for eighteen films rather than twelve. Keen to expand the company, Walt reasoned that if he had to make cuts, they wouldn't be in the animation department. He decided instead to do away with Davis's contract, rather than increase her month's salary to $250 as he'd originally promised, offering to pay her, but only for the days she worked—the plan being that all her scenes, for the whole of 1925, could be shot in eighteen days (one day per film). "By the end of the fourteenth picture, we were getting more toward gags and less direction of children," Davis recalled. "Consequently they wanted me to work maybe one day every three weeks and pay me by the day. My mother wouldn't go for that. She was a pretty sharp cookie."

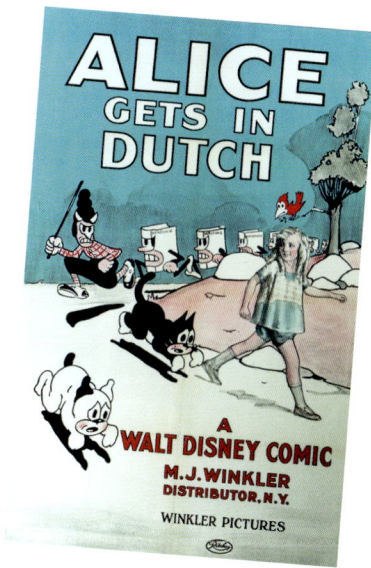

ABOVE: Poster for 1924's *Alice Gets in Dutch*, an Alice Comedy

BELOW: Walt, circa August 1923, in Los Angeles' Los Feliz district, behind his uncle Robert's house

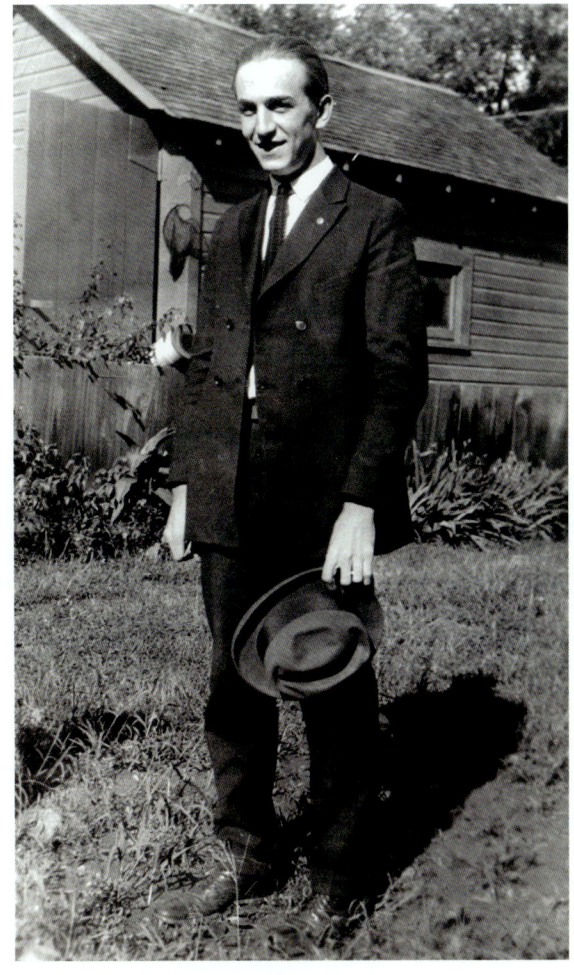

Walt Dis

ALICE COMEDIES

ney Comics

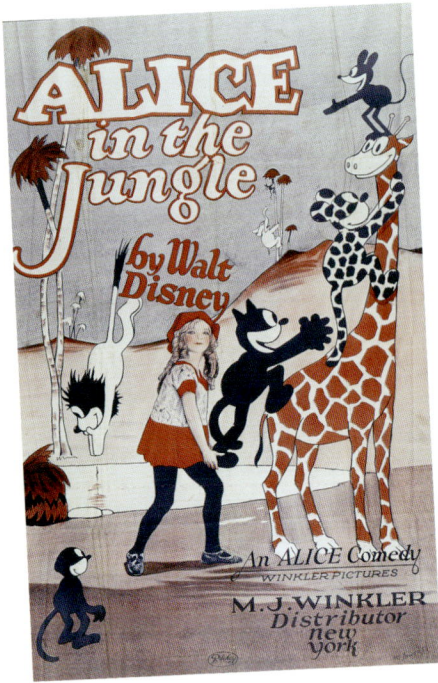

After fourteen films, Davis's mom decided not to renew her daughter's contract, so the last short Davis filmed was *Alice Gets Stung* in January 1925. (In the late 1930s, Davis joined the studio's Ink and Paint Department, and also worked as a dancer, actress, and journalist.)

With production beginning on *Alice Solves the Puzzle* in February 1925, Walt needed a new Alice. He hired the bubbly and energetic five-year-old Margie Gay, whose Clara Bow-style pageboy bob was more reminiscent of the 1920s flappers than the look Mary Pickford presented. (Perhaps fittingly, Gay's talents included flapping her arms a lot.) At around the same time, Walt reached out to former Kansas City colleagues Rudy Ising, Max Maxwell, and brothers Hugh and Walker Harman, and implored them to join him.

The following month Walt began work on *Alice's Egg Plant*, the first short in which Alice's black cat sidekick was officially referred to as Julius; it starred six-year-old Dawn O'Day as Alice. Considered by many to be one of the best of the series (not least because Iwerks and company were using animation cels of a marked reduced density, which allowed for a better quality image and more consistent exposure), the short turned out to be Dawn's first and last outing as Alice. Having started acting at three, the young actress supported her parents financially through her work; and simply put, Walt's monetary "rewards" weren't enough for the O'Days. So, Walt rehired Gay, who went on to star in thirty-one Alice Comedies in all.

As Disney focused more and more on animation, Alice, the nominal focal point of the series, was soon reduced to brief appearances in her own films. August 1925's *Alice Chops the Suey* featured little more than a cameo from Gay as Julius took over the lead, rescuing Alice from an evil Jinn. The heroic cat continued to reveal his plucky, swashbuckling side in *Alice on the Farm* and *Alice Foils the Pirates*

PAGES 34–35: Lobby cards, such as this one featuring actress Virginia Davis in the Alice Comedies, were posted outside movie theaters or in the lobbies to promote films.

ABOVE LEFT: Poster for 1925's *Alice in the Jungle*, an Alice Comedy

BELOW: Walt chats with the second actress to play Alice, Margie Gay, circa 1926.

OPPOSITE: Publicity still featuring Walt, Margie, and Roy, circa 1925

PAGES 38–39: Twelve final frames from 1925's *Alice Gets Stage Struck*, an Alice Comedy starring Margie Gay as Alice

> "I want the characters to be somebody. I don't want them just to be a drawing."
>
> — WALT DISNEY

An Illustrated Journey Through Time

among other shorts. (It was around this time, too, that the studio's male employees held a mustache-growing competition. While most went back to their pre-contest appearance when it ended, both Iwerks and Walt retained theirs. Walt's trademark mustache had arrived.)

Walt and Winkler signed their third contract in early 1926. This one called for twenty-six more Alice Comedies. The first thirteen were to be delivered at three-week intervals, and the rest were to be at a rate of one every fortnight. While the studio's fee was lowered from $1,800 per picture to $1,500, Walt successfully negotiated a percentage of the profits and a share of merchandising revenue. He also insisted that "all matters regarding [the] making of comedies are left to me." By this point, Ising and the rest of the Kansas City animators had finally arrived, working alongside Ruth Disney and Irene Hamilton, Walt's and Ham's sisters, who'd joined the Ink and Paint Department. "It was the same group, and almost the same equipment," noted Ising.

OPPOSITE: Six final frames from 1925's *Alice Solves the Puzzle*, an Alice Comedy starring Margie Gay as Alice

ABOVE: Rollin "Ham" Hamilton, Roy Disney, Hugh Harman, Walt Disney, Margie Gay, Rudy Ising, Ub Iwerks, and Walker Harman outside Disney's Hyperion Studio, circa 1926

To cope with the extra staff and increased workload, Walt and Roy put a $400 deposit on a vacant lot at 2719 Hyperion Avenue in July 1926 and began work on what was to become their first purpose-built animation studio, a fabled location that would witness the birth of Mickey Mouse, the Silly Symphonies, and *Snow White and the Seven Dwarfs*.

The first Alice series film produced at Hyperion—by now renamed Walt Disney Studios—was *Alice Charms the Fish*, which was also the first of the series to be released nationally in September 1926. Although Walt had relinquished all animation duties, he continued to produce and direct and would lead the animators in crafting the stories. "Walt would have an idea: let's let Alice be a fireman in this one, or let's let Alice go fishing, or whatever it was," recalled Ising who eventually, in 1929, founded Warner Cartoons with Hugh Harman. "Then we'd work up fire gags or fishing gags, and Walt would put them all together to tell the story."

While Walt was fond of recycling jokes and repurposing plots to keep on top of the punishing production schedule, the animators, under Iwerks's continued tutelage, further honed their craft, as Walt pushed for more personality in the animation.

When Hamilton left in late 1926, after clashing with Walt, he was replaced by Isadore (Friz) Freleng, another Kansas City artist, who would find fame ultimately outside Disney, with Looney Tunes, Merrie Melodies, and The Pink Panther. Freleng remembers animating a sequence for

41

ABOVE: Four final frames from 1925's *Alice Wins the Derby*, an Alice Comedy starring Margie Gay as Alice

Alice's Picnic with which Walt was completely taken. "The trick in the early days was just to make [the characters] move," the artist recalled in *Walt in Wonderland*. "But when Walt got into distinguishing one from another by personalities, it changed the whole thing." Assigned a scene of a mother cat washing her kittens, Freleng drew one crawling out of the tub. "He was so small he had to hang on the edge, then drop down," he recalls. "Then the mother grabbed him and put him back in the tub. Walt called that to everybody's attention. He says, 'Friz made him act like a little kid. That's what I want to see. I want the characters to *be* somebody. I don't want them just to be a drawing.'"

Toward the end of 1926, as the studio embarked on *Alice's Circus Daze*, in which Alice and Julius work on a high-wire act, Walt parted company with Gay. The fourth and final Alice was twelve-year-old Lois Hardwick, a child actress, who affected a young flapper-type image as

well, and would appear in ten Alice series films in total. She began with *Circus Daze*, though by then the series had become Alice Comedies in name only, with the bulk of the action carried by Julius the cat.

In all, Walt made fifty-six Alice Comedies from 1924 to 1927, plus the 1923 pilot, before their popularity waned. Moreover, in the five years since leaving Kansas, Walt had risen, phoenixlike, from the bankruptcy of Laugh-O-gram to running a successful animation studio.

But bigger and better was still to come. And when Carl Laemmle, legendary head of Universal Pictures, called Mintz to say his studio would like a cartoon series about a rabbit, Mintz, in turn, called Walt and together with Iwerks, they set about creating what would become the first of the Oswald the Lucky Rabbit cartoons. Not long after, Walt and Iwerks would dream up Mickey Mouse.

And the rest is animation history.

ABOVE: Four final frames from 1927's *Alice the Whaler*, an Alice Comedy starring Lois Hardwick as Alice

ial
2
Everything Would Be Nonsense

An Animated Wonderland

WALT DISNEY had toyed with the idea of making a full-length *Alice* animated feature as early as 1932. And given his love for Lewis Carroll's books, Disney was keen to adapt *Alice in Wonderland*, going so far as to purchase the rights to Sir John Tenniel's illustrations, and aiming to cast either Mary Pickford or his original Alice, Virginia Davis, in the lead. But none of the various treatments Walt commissioned passed muster.

Then, in 1933, Paramount Pictures released its own version, a star-studded live-action feature directed by Norman McLeod, with Charlotte Henry as Alice, W. C. Fields as Humpty-Dumpty, Cary Grant as the Mock Turtle, and Gary Cooper as the White Knight. So, Walt switched his attentions to *Snow White and the Seven Dwarfs*, which was released in 1937 and won him an Honorary Academy Award for significant screen innovation.

Yet the allure of *Alice* still continued to haunt Walt, and in 1936 Disney released a cartoon short loosely based on Carroll's *Through the Looking-Glass*, which saw Mickey Mouse going *Thru the Mirror* (the short's title) into a room filled with weird, fantastical characters. Disney's attention to Carroll's book even garnered some screen time in the opening titles of his second animated full-length film, *Pinocchio*, released in 1940, which featured a copy of *Alice in Wonderland* on a bookshelf alongside J. M. Barrie's *Peter Pan*, which he would also bring to the big screen.

ABOVE: Alice talks with the Cheshire Cat, from 1951's *Alice in Wonderland*. Artist: Disney Studio artist. Medium: Graphite.

BELOW: Final frame from the opening sequence of 1940's *Pinocchio*. Notice the book, with the spine titled *Alice in Wonderland* off to the left, next to *Peter Pan*. Both films were on Walt's upcoming slate at the time.

Mickey dances with the Queen of Hearts from 1936's *Thru the Mirror*, a Mickey Mouse cartoon.
Artist: Disney Studio artist. Medium: Colored pencil, graphite.

SHORTS
"March of the Cards"
Thru the Mirror

This eight-minute Mickey Mouse cartoon, released on May 30, 1936, was directed by Dave Hand and packed full of Lewis Carroll-esque imagination, starting when Mickey falls asleep while reading *Thru the Looking-Glass*. In his dream state, Mickey enters, through the titular mirror, an alternate dimension of anthropomorphic household items and furniture. After eating a walnut, Mickey first grows, then shrinks in size, jump ropes a telephone, tap-dances à la Fred Astaire with a pair of gloves, duels a jealous King of Hearts (modeled after Charles Laughton) for the attentions of his wife (a Greta Garbo-esque Queen of Hearts), and is pursued by a deck of cards before, finally, his alarm clock wakes him up.

OPPOSITE: **As Mickey sleeps, his dream self steps** Thru the Mirror **in this 1936 short (of the same name), directed by Dave Hand. Artist: Disney Studio artist. Medium: China marker, graphite (top left); graphite (top right and below).**

ABOVE: **Six final frames from** Thru the Mirror

49

Walt Disney's Alice in Wonderland

ABOVE AND RIGHT: After eating a nut in *Thru the Mirror*, Mickey grows and then shrinks in size before skipping rope with his tabletop telephone. Artist: Disney Studio artist. Medium: Graphite, colored pencil.

TOP RIGHT AND OPPOSITE: Three final frames of the same scene

50

Walt Disney's Alice in Wonderland

"CARDS SHUFFLE!"

52

An Illustrated Journey Through Time

Mickey dances with a pair of gloves, and ultimately the Queen of Hearts, before dueling with the King of Hearts and finally running back to his bed and awakening from his "dream" in this artwork from *Thru the Mirror*.
OPPOSITE, TOP LEFT: **Artist:** Disney Studio artist. **Medium:** Graphite.

OPPOSITE, CENTER AND BOTTOM LEFT: **Artist:** Disney Studio artist. **Medium:** Graphite, colored pencil.
CENTER RIGHT: **Artist:** Disney Studio artist. **Medium:** Graphite.
OPPOSITE, TOP AND BOTTOM RIGHT, AND THIS PAGE TOP, CENTER LEFT, AND BOTTOM: **Seven final frames**

ELASTIC MIRROR SNAPS BACK—

53

LEFT AND OPPOSITE, BOTTOM: In these unused concepts from 1951's *Alice in Wonderland*, the White Rabbit has jam poured and smeared over him by the Mad Hatter and the March Hare. Artist: David S. Hall. Medium: Gouche, ink, graphite.

ABOVE: Walt, front center, with his team of filmmakers, including Al Perkins, Bill Cottrell, T. Hee, and Dave Hand

The brief call-out in *Pinocchio* to Carroll's work (four years after *Thru the Mirror*) perhaps further hints at what was to come from Disney. For even by 1938, flush with *Snow White*'s success, Walt had again turned his attention back toward *Alice in Wonderland*, determined to find a way to translate it to the big screen. After registering the title with the Motion Picture Association of America, Disney enlisted studio storyboard artist Al Perkins and art director David S. Hall to develop a story reel.

As Perkins wrestled with turning Carroll's episodic tale into a cohesive story, Hall crafted hundreds and hundreds of drawings based on Carroll's character descriptions and Tenniel's illustrations, which were then filmed with a voice track added. But, the following year, when Walt viewed the completed story reel, he was distinctly unimpressed. He felt Hall's decision to stick close to Tenniel's creations made his designs difficult to animate. Moreover, Walt deemed both Hall's designs and Perkins's treatment "dark and grotesque" and scrapped them. (Ironically, several of Hall's visual ideas did make their way, almost exactly, into the final animated movie.)

The outbreak of World War II, and the Japanese attack on Pearl Harbor in December 1941, which precipitated America's entry into the conflict, put any further development of *Alice* on hold for the next few years as the war in Europe and Asia raged and the demands of making *Pinocchio*, *Fantasia*, and *Bambi*—alongside the underwhelming box office of *Pinocchio* and *Fantasia*—pushed the studio to the edge of bankruptcy.

But Walt hadn't given up on *Alice* entirely and, in 1944, he assigned

An Illustrated Journey Through Time

Fantasia animators Bill Cottrell and T. Hee to come up with a novel take on the material, even employing the services of a psychoanalyst to help his story department find a new direction. But Cottrell and Hee didn't "find" reason enough to adapt Carroll's *Alice*, reporting back that "it is a fallacious argument to say that a picture should be made just on the grounds that it is a literary classic."

Walt remained undaunted. He would have his *Alice*.

The following year, shortly after the end of World War II, British author Aldous Huxley (*A Brave New World*), who had previously adapted literary classics *Jane Eyre* and *Pride and Prejudice* for Hollywood, was hired to write an *Alice in Wonderland* script based on Carroll's book and life. The plan was to produce a live-action/animated hybrid, much like the Alice Comedies series, with either Luana Patten, who would star in Disney's *Song of the South*, Ginger Rogers, who had recorded an album based on *Alice in Wonderland*, or Lisa Davis, who would later voice Anita Radcliffe in *One Hundred and One Dalmatians*, to play Alice.

But Walt didn't warm to Huxley's treatment, deeming it "high on literacy but low on humor." (Many years later, British dramatist Dennis Potter penned the similarly themed *Dreamchild*, which explored the darker side of Charles Dodgson/Lewis Carroll's relationship with Alice Liddell.) By then, Walt realized he could only do justice to *Alice* as an entirely animated feature, and in 1946 he began work in earnest to make that finally happen.

TOP RIGHT: Alice grows tall in the forest from 1951's *Alice in Wonderland*. Artist: David S. Hall. Medium: Gouache, ink, graphite.

TOP LEFT: Hall's style reflects the influence of Sir John Tenniel's tall Alice from Lewis Carroll's *Alice's Adventures in Wonderland*, 1865 edition. Medium: Preliminary pencil drawing, inked, and transferred to woodblock engraving.

ABOVE: Hall's own influence is seen in this final frame from 1951's *Alice in Wonderland*.

PAGES 56–59: Hall's darker thematic tone can be seen in many of his concepts. Medium: Gouache, ink, graphite.

PARKS
"The Unbirthday Song"
Mad Tea Party Attraction

Inspired by the Un-birthday sequence in Disney's 1951 animated *Alice in Wonderland*, the Mad Tea Party attraction debuted at Disneyland's opening day celebration on July 17, 1955, as a part of the original Fantasyland. This topsy-turvy, Wonderland-themed ride at the Park in Anaheim has since gone on to spawn similar rides at the Magic Kingdom in Walt Disney World, Tokyo Disneyland (Alice's Tea Party), Disneyland Paris (Mad Hatter's Tea Cups), and Hong Kong Disneyland (Mad Hatter Tea Cups)—all of which are subtly different, with Walt Disney World's and Tokyo Disneyland's featuring a central giant teapot from which the Dormouse appears.

This 1953 concept of the Mad Tea Party attraction envisioned the Mad Hatter and March Hare standing on a center table and Japanese garden lanterns strung overhead. Artist: Bruce Bushman. Medium: Colored pencil, chalk/pastel.

Disneyland's Mad Tea Party Statistics

One main revolving platform

Three revolving platforms within the main revolving platform

Six teacups on each of the smaller revolving platforms

Eighteen spinning teacups total

Each platform—and each individual teacup—spin at different speeds.

Fastest spinning capacity is the orange diamond teacup.

Second fastest spinning capacity is the purple teacup.

Slowest spinning capacity are the two heart teacups.

RIGHT: Three teacups from a 1978 renovation color concept of the Mad Tea Party attraction. Artist: Kim Irvine. Medium: Acrylic.

Time Line

✳ **1954:** Bruce Bushman creates a ride layout—calling out a never-developed teapot, sugar bowl, and creamer.

✳ **1954–1955:** Arrow Development, an amusement park ride–design and manufacturing company that opened in 1945—and in which Disney purchased a third of the company in 1960—manufactures and assists with installation at Disneyland.

✳ **July 17, 1955:** Attraction opens with an unembellished platform, located directly behind Sleeping Beauty Castle in Disneyland's Fantasyland.

✳ **Fall 1955:** Spiral design is painted on the platform a few months after opening.

Walt Disney's Alice in Wonderland

✸ **1957:** Breaks and other mechanics are installed to limit how fast the teacup could be spun.

✸ **October 1, 1971:** Magic Kingdom's version at Walt Disney World opens in Fantasyland in its current location, but without a roof over it.

✸ **1972:** Disneyland's ornamental arches added as a decorative connection in between the light posts

✸ **1974:** Roof constructed over Walt Disney World's version to protect it from rainfall

✸ **1978:** Disneyland's platform, teacups, and operator's structure are repainted to a new color scheme.

✸ **1982:** Attraction closed and deconstructed at Disneyland

✸ **1983:** Reconstructed at Disneyland in its present location near the Matterhorn Bobsleds and the Storybook Land Canal Boats

✸ **May 25, 1983:** Attraction reopens at Disneyland in a new space and with Japanese garden lanterns strung overhead.

ABOVE: **Artist: Kim Irvine**

62

An Illustrated Journey Through Time

✻ 1985: John Drury and Greg Paul design an attraction poster used at Disneyland and Walt Disney World.

✻ March 8, 1986: Alice's Tea Party opens in Fantasyland at Tokyo Disneyland.

✻ April 12, 1992: Mad Hatter's Tea Cups opens in Fantasyland at Disneyland Paris.

✻ 1998: Christopher Smith redesigns the attraction poster for Alice's Tea Party at Tokyo Disneyland.

✻ 2004: Disneyland's mechanics adjusted to make it harder for the rider to spin the cup faster.

✻ Spring 2005: One teacup at Disneyland is painted gold in celebration of the Park's fiftieth anniversary.

✻ September 12, 2005: Mad Hatter Tea Cups opens at Hong Kong Disneyland.

Alice falling down the rabbit hole, from 1951's *Alice in Wonderland*. Artist: Mary Blair. Medium: Acrylic.

An Illustrated Journey Through Time

> "If I hadn't regarded it as one of the masterpieces of all time, for both adults and children, I would not have undertaken a film version. I undertook it with [the] greatest respect."
>
> — WALT DISNEY

TOP: Sir John Tenniel's Wonderland entrance from Lewis Carroll's *Alice's Adventures in Wonderland*, 1865 edition. Medium: Preliminary pencil drawing, inked, and transferred to woodblock engraving.

ABOVE LEFT: Alice enters Wonderland through a series of doors from 1951's *Alice in Wonderland*. Artist: Mary Blair. Medium: Gouache.

ABOVE: Influences from both Blair and Tenniel are evident in this final frame from 1951's *Alice in Wonderland*.

Once again, the first challenge was how best to translate Carroll's verbal nonsense and the episodic storytelling style of the books into the visual medium. Given the lack of a strong narrative through-line—with Alice's journey into Wonderland, essentially, a meandering series of encounters with bizarre characters—finding a way to unify the disparate episodes was key. "[Carroll] was interested more in ideas and fantasy, and their intermingling, than the rules of suspense and story structure," wrote Disney in 1951. "Some people told us because the books are pure fantasy, the basic laws of story progression need not apply . . . [but] it was imperative we create a plot structure.

"Carroll had not had need for such a thing," Disney added in retrospection. "We decided Alice's curiosity was the only possible prime mover. The result is a basic chase pattern that culminates when Alice, after her strange adventures, returns to the world of reality."

Walt understood he was "attempting to film a classic loved by millions." But he knew he couldn't film it as is and was determined to retain the spirit of the books rather than stick too closely to it. That way he could layer his own sense of entertainment on top of Carroll's world. "Our big problem was to bring it to the screen in a manner that would please everybody," he told legendary Hollywood gossip columnist Hedda Hopper in December 1950. "But in the beginning we had too much material. Some had to be eliminated. The question was: what to cut?"

Since there are around eighty characters in both books, Walt reasoned it would be impossible to include them all, given the film's planned eighty-minute running time. Some judicious editing was required. "We combined a few characters, rearranged some episodes, condensed dialogue, keeping, we believe, the Carroll flavor," Walt told Hopper. "I am not finding fault with the way Lewis Carroll told his immortal nonsense. If I hadn't regarded it as one of the masterpieces of all time, for both adults and children, I would not have undertaken a film version. I undertook it with [the] greatest respect." And before Walt did anything, he said that he "tried out every episode in both *Alice* books on our own test audience of some five hundred people."

The Mock Turtle and the Gryphon were cut after tests indicated, according to Disney, that "the sad and weepy" Mock Turtle and Gryphon were "without other compensating interest." Other characters also met a similar fate. Humpty Dumpty was considered "too talky" (and in actuality wasn't even a Carroll creation, but rather a nursery rhyme character who appeared in the second book). Some were scratched simply because they were deemed too unpleasant or annoying by the test audience. "Many characters in the two books antagonized, repelled, or confused the little girl and have similarly affected even the most steadfast of *Alice*'s admirers," Walt noted. "Some were pretty callous, and several were depressingly lugubrious. The child that turns into a pig in Alice's arms was revolting, according to one of our early tests."

Then there were the characters that were simply amalgamated. "We combined the four Queens and the Duchess into one figure, the raucous Queen of Hearts, who keeps demanding more decapitations," said Walt,

TOP: Sir John Tenniel's King and Queen of Hearts from Lewis Carroll's *Alice's Adventures in Wonderland*, 1865 edition. Medium: Preliminary pencil drawing, inked, and transferred to woodblock engraving. **CENTER:** Queen of Hearts with a flamingo croquet mallet story sketch. Artist: Disney Studio artist. Medium: Charcoal, Conte crayon, pastel. **ABOVE:** Queen of Hearts character study. Artist: Mary Blair. Medium: Gouache, graphite. **RIGHT:** Queen of Hearts model sheet. Artist: Disney Studio artist. Medium: Black line.

who reportedly based the character's look and personality on Hopper's gossip-columnist chief rival, Luella Parsons; she was notoriously bad-tempered and had a severe bun of dark hair. The Cheshire Cat was given the Jabberwock's poem to sing, while the White Rabbit was bestowed more prominence, popping up in the film's Tea Party scene, wherein the Mad Hatter and March Hare were given the Un-birthday lines, which were part of Humpty Dumpty's colloquy in *Through the Looking-Glass*. Disney also took on board Al Perkins's suggestion that the Zen-like Cheshire Cat should appear to Alice throughout to help anchor both her journey through Wonderland and the audience's.

Another change was shifting the history lesson espoused in the Caucus Race to the opening. "Putting it there gives more coherence to all that follows, since it puts the reason for Alice's descent into the rabbit hole where it is most effective dramatically, at the beginning," said Walt. But despite the changes, Disney considered that "no violence is done to Carroll's mood, nor to any of the character relationships."

TOP: Alice approaching the White Rabbit's home with the Cheshire Cat watching overhead. Artist: Disney Studio artist. Medium: Gouache.

ABOVE: Unused concept of the Jabberwock character. Artist: Disney Studio artist. Medium: Pastel.

LEFT: Alice's cat peers into the rabbit hole. Artist: Mary Blair. Medium: Gouache, graphite.

BELOW: The Door Knob in a cleanup animation drawing. Artist: Frank Thomas. Medium: Colored pencil, Conte crayon, graphite.

BOTTOM: The talking Door Knob in a final frame

In fact, the only invented character was the officious talking Door Knob, who Alice meets at the bottom of the rabbit hole, guarding the entrance to Wonderland and is fond of silly puns ("You gave me quite a turn. . . ."). Originally envisioned in Hall and Perkins's story reel as a speaking "Drink Me" bottle, the character was created "to avoid a long explanatory monologue at the beginning of the story and to give Alice a foil to talk to," said Walt, who noted, too, that the Door Knob character was "approved by some of the strictest *Alice* purists in England."

Walt also wanted to give the film an emotional core, adding moments and dialogue to make Alice more sympathetic, having her appear frightened or regretful, as in the scene in Tulgey Wood, when she sits on a tree stump and cries, bemoaning the fact she followed the White Rabbit into Wonderland in the first place. Tulgey Wood was also to be the setting for the scene of a meeting between Alice and the White Knight, one of the few characters who was kind to Alice. And although Walt liked the sequence (the White Knight was said to be designed as a caricature of Disney), he felt Alice should learn her lesson by herself; so Walt scrapped it. More cuts followed. One, again in Tulgey Wood, involved a scene in which Alice encountered the Jabberwock. It had even been storyboarded, with humorist Stan Freberg cast as the Jabberwock's voice. Further, a song was written for the sequence, "Beware the Jabberwock." But in the end, Walt excised it in favor of a sequence involving the Walrus and the Carpenter. Ultimately, no fewer than thirteen story men were credited as working on *Alice*. Even so, by the time production began on June 12, 1947, the script was said to still be in a state of flux.

OPPOSITE: Concept and background art and final frames from the Walrus and the Carpenter segment in 1951's *Alice in Wonderland*

TOP LEFT: Artist: Mary Blair. Medium: Gouache.

CENTER RIGHT: Artist: Disney Studio artist. Medium: Gouache.

BOTTOM LEFT: Artist: Mary Blair. Medium: Gouache.

PARKS
"In a World of My Own"
Alice in Wonderland Dark Ride

ABOVE LEFT: Walt and characters at the June 14, 1958, attraction's dedication. Alice is played by Mouseketeer Karen Pendleton. ABOVE RIGHT: A 1958 attraction poster. Artist: Sam McKim. Medium: Screen print.

First opened on June 14, 1958, as part of Disneyland Park's Fantasyland, the Alice in Wonderland dark ride was designed primarily by Claude Coats, who started his Disney career as an animation background painter at the studio. Coats worked on numerous movies, including *Snow White and the Seven Dwarfs*, *Fantasia*, *Dumbo*, *Lady and the Tramp*, *Cinderella*, and *Peter Pan*. But in 1955 Coats transferred to WED Enterprises (the predecessor to Walt Disney Imagineering), where he helped design attractions for Disneyland (Pirates of the Caribbean, the Haunted Mansion, the Submarine Voyage, and the Grand Canyon and Primeval World dioramas of the Disneyland Railroad) before turning his attention to Walt Disney World's Mickey Mouse Revue and several World Showcase pavilions at Epcot.

Alice in Wonderland was Coats's third dark ride, but the first for which he was largely responsible. Guests today still ride in caterpillar-shaped cars and head into a rabbit hole, whereupon they encounter various characters and settings from the 1951 animated movie, including Tulgey Wood, the hedge maze, the Garden of Live Flowers, and

An Illustrated Journey Through Time

ABOVE: A 1975 revised ride entrance concept. Artist: Marty Kline.

ABOVE RIGHT: A 1958 attraction overview. Artist: Sam McKim. Medium: Gouache, pen and ink.

ABOVE: A 1955 exterior sketch showing Guests at the railing and on the ride vehicle. Artist: Claude Coats. Medium: Pencil.

then end with the Mad Tea Party. "He designed [. . .] all the concepts, the story, the track layout, the backgrounds, the model, even the ride vehicle," said Coats's son, Alan. "Alice was more dimensional than the other rides since it was done later and also had the unusual outside track section."

Coats initially wanted to make the ride car out of playing cards. But Walt didn't like it, and told him to do a caterpillar instead. "Later the legal people came round and had a patent application for it," Coats recalled in a 1999 article that appeared in *The E Ticket* magazine. "I said, 'I didn't do it; it's Walt's idea.' But they said, 'You did the drawing, so you get the patent.' I think they gave me ten dollars to sign the patent over to the studio."

The ride was refreshed in 1982–1984 when a new voice track featuring Kathryn Beaumont, voice of the heroine from the 1951 *Alice*, was added, and again in 2014 when there were several impressive enhancements, including additional animation effects.

Coats retired in 1989 and received the Disney Legends Award in 1991. He remains one of the select few Disney employees to receive a fifty-year service award. "I used to admire Claude's painting over at the studio," said Disney Legend and retired Imagineering sculptor Blaine Gibson, who worked on the sculpting of the caterpillar vehicles. "I always thought his facility in a rather broad range of art techniques was just amazing. He had strong ideas in his head, and eventually they would always come out right."

71

Walt Disney's Alice in Wonderland

THIS SPREAD: Artwork and photos depicting the journey of the attraction

72

An Illustrated Journey Through Time

73

Kathryn Beaumont (Alice) in live-action reference footage shot for 1951's *Alice in Wonderland*

An Illustrated Journey Through Time

FAR LEFT, LEFT, AND ABOVE: Alice in three cleanup animation drawings. Artist: Milt Kahl. Medium: Colored pencil, graphite.

In addition to the story, the other major challenge for Walt was finding the right voice for *Alice*'s most beloved and iconic of characters. "Voices and music are almost as important in animated cartoons as the drawings themselves. Voices key the animation, and precede the drawings, so the animation can be timed and adjusted to the spoken words," Walt once explained. "And voices for fantasy, and for the characters of fantasy, require a very creative kind of casting."

Walt further noted another predicament: "the necessity, for the purpose of engendering mood, of authentic British inflections."

Walt engaged W. Cabell Greet, an English professor at Barnard College, Columbia University, and one of the foremost authorities on "phonetic" speech, as special consultant on the production. Since Carroll was English, there was a popular opinion that Alice should speak with an Oxfordian accent. But other *Alice* devotees insisted that she speak with an unmistakably American (Back Bay section of Boston), Canadian, or Australian accent. "It was essential it please English-speaking people everywhere," Walt added. "When I was in Great Britain I found the people only insisted that Alice be English. They were not particularly concerned with the other creatures. They felt that their voices should simply be characteristic of the characters." In the end, Walt wanted a universally accessible accent for Alice and tasked Professor Greet to scientifically determine a phonetic speech pattern that would be spoken by the character throughout the film.

Of paramount importance was finding the perfect Alice. "Our whole project largely depended on finding the voice that would give our animation of Alice warm and vibrating life," Walt said. Walt auditioned around two hundred American and British hopefuls before casting the

ABOVE: Kathryn Beaumont reviewing Mary Blair's artwork with Walt

BELOW: Beaumont looking on as Marc Davis animates the character she voiced

75

Tweedledee and Tweedledum, from 1951's *Alice in Wonderland*. **ABOVE**: Walter Georgov (Tweedledee) and Jimmie Thompson (Tweedledum) in live-action reference footage. **BELOW**: Cleanup animation drawing. Artist: Ward Kimball. Medium: Graphite, ink. **BOTTOM**: Final frame

OPPOSITE: Large Alice inside the White Rabbit's home. **TOP LEFT**: Director Hamilton "Ham" Luske directs Kathryn Beaumont (Alice) in live-action reference footage. **TOP RIGHT**: Cleanup layout. Artist: Charles Philippi. Medium: Graphite. **CENTER**: Background painting. Artist: Disney Studio artists. Medium: Gouache. **BOTTOM**: Three final frames

eleven-year-old, English-born Kathryn Beaumont. He'd seen her in the 1948 MGM musical *On an Island with You* and decided she "had enough accent to please the English, but it is not too British for American audiences." Beaumont needed also to sing and was to provide the physical model for Walt's Alice. A few years later, she also would voice Wendy in *Peter Pan*.

For the Mad Hatter, meantime, Walt chose vaudeville and radio performer Ed Wynn, who went on to star in numerous Disney features, including *Mary Poppins*, 1965's *That Darn Cat!*, and *The Absent-Minded Professor*, while comedian Jerry Colonna was picked to play the frenetic March Hare. As the Cheshire Cat, Walt hired one of the studio's most recognizable talents, Sterling Holloway, who had played the Frog footman in Paramount's 1933 *Alice* and would later voice Disney's Winnie the Pooh. Others in the cast included Richard Haydn as the Caterpillar; Verna Felton as the Queen of Hearts; Bill Thompson as both the White Rabbit and Dodo; and J. Pat O'Malley as Tweedledee, Tweedledum, the Walrus, the Carpenter, and the oysters.

This was a truly star-studded voice cast and marked one of the first times Disney featured their names on the movie's poster.

It was also the first time since the 1940s that Walt had decided to shoot a full-length, live-action version of the film for his animators to use as a guide. Having recorded their voice tracks, Beaumont and the rest of the cast were required to act out their roles on a near-empty soundstage with minimal props and sets. The resultant black-and-white footage would aid the animators in their craft, helping to guide their animation in a manner that would allow for an even greater sense of lifelike movement, grounded in reality.

During filming, however, Wynn had trouble miming to his own vocal track. "It drove him crazy. He said, 'I can't do it. Why don't you turn that darn voice track off and I'll remember roughly what I said," recalled *Alice in Wonderland*'s animation director, Ward Kimball. "We agreed, saying, 'We'll just use one little mike with no attempt at fidelity to pick up what you say.' Well, the nonsense Ed [Wynn] ad-libbed on that soundstage was a lot funnier than some of the recorded stuff we had carefully written out for him. When Walt saw the black-and-white test he said, 'Let's use that sound track! That's great!'

"The sound department hit the fan, complaining, 'There's too much background noise!' To which Walt replied, 'That's your problem' and walked out of the room," Kimball remembered, noting not everyone was thrilled with the situation. (While the footage was meant to be destroyed once the animators had finished using it as reference, some survived, and can be viewed on the *Alice in Wonderland* DVD/Blu-ray as well as via the Internet.)

PARKS

"The Caucus Race"

Alice in Wonderland *Floats* in the Main Street Electrical Parade

The original Main Street Electrical Parade debuted at Disneyland on June 17, 1972, and notably featured a string of light-up floats themed to *Alice in Wonderland* set to synthesizer music that combined the songs "Alice in Wonderland," "The Unbirthday Song," and the parade's main theme, the "Baroque Hoedown."

The parade ran consecutively until 1975, when it was briefly replaced by a patriotic-themed parade honoring the American Bicentennial anniversary. With some updates, it started up again in 1977 and continued (with a few suspensions in 1983 and 1984) until November 25, 1996. The floats were then fully refurbished and moved to Walt Disney World's Magic Kingdom, where they ran from May 1999 to April 2001, and were then transported to Disney California Adventure, where they ran as Disney's Electrical Parade from July 2001 to April 2010 (with some updates and pauses through the years). The floats returned to Walt Disney World's Magic Kingdom in June 2010 and continue to run there to this day.

Duplicate versions and other variations of the parade have been created over the years, operating at Walt Disney World, Disneyland Paris, and Tokyo Disneyland. The Tokyo Disneyland Electrical Parade Dreamlights version that began June 1, 2001, is of particular note to *Alice* fans, as it features Alice sitting atop a huge Cheshire Cat.

TOP: A 1971 concept for the *Alice*-themed floats in the Main Street Electrical Parade. Artist: Unknown.

COUNTERCLOCKWISE FROM TOP LEFT: Opening of Disney's Electrical Parade with *Alice*-themed floats seen in the background, at Disney California Adventure in 2008; Alice atop a mushroom float, from Disneyland, circa 1970s; the Cheshire Cat float, from the Tokyo Disneyland Electrical Parade Dreamlights in 2001; and butterfly atop a mushroom float, from Disneyland, circa 1980

Since Walt considered Paramount's *Alice* movie to be grotesque and unpleasant, he was determined to make his adaptation more playful and full of music. In the manner of a traditional Broadway musical, every sequence/character in Wonderland was to be given a song, based around Carroll's imaginative verses and poems. And, to that end, the final film contains the greatest number of songs any Disney animated feature has ever had—fourteen in total; most of them were written by the songwriting team of Sammy Fain and lyricist Bob Hilliard, who Walt found in New York's famous Tin Pan Alley (a part of the city where many music publishing houses were based). Together with Oliver Wallace's Oscar-nominated score, Fain and Hilliard's songs help unify the disparate episodes of the story, navigating the madness, mayhem, and multiple characters.

The toughest sequence song to write was for the Tea Party, and in the end, Walt called upon the *Cinderella* team of Mack David, Jerry Livingston, and Al Hoffman, who came up with the now classic "The Unbirthday Song." Ultimately, more songs were commissioned than used, although "Beyond the Laughing Sky," which Alice was to sing at the start, became, with different lyrics, the title song "The Second Star to the Right," for *Peter Pan*, which was in production at the same time.

ABOVE: Music composer Oliver Wallace, who composed the score for 1951's *Alice in Wonderland*, talks with Walt. **LEFT:** Disney sound-effects wizard James "Jimmy" Macdonald (further back) sits with another sound artist (foreground) and records jug whistles. **BELOW:** Alice rests on the mushroom and listens to the Caterpillar. Cleanup animation drawing. Artist: Milt Kahl. Medium: Graphite. **BOTTOM:** Corresponding final frame

𝒜 𝐿𝒜𝑅𝒢𝐸 part of the early success of Carroll's *Alice's Adventures in Wonderland* was, undoubtedly, due to the illustrations of *Punch* cartoonist Sir John Tenniel that accompanied the book's original printing. And, for many generations, these versions of Alice, the Hatter, White Rabbit, and other lead characters are what the general population had in mind when they thought of Wonderland. "*Alice in Wonderland* presented the most formidable problems we have ever faced in translating a literary classic into the cartoon medium," said Walt at the time of the film's release. "The appearances of the whole Carroll brood are very definitely conceived in the minds of millions of children and grown-ups. These mental images, of course, derive from the Tenniel illustrations."

However, when it came to actually putting *Alice* on-screen, Tenniel's complex pen-and-ink designs did not really lend themselves to the

Sir John Tenniel's cards painting the roses red from Lewis Carroll's *Alice's Adventures in Wonderland*, 1865 edition.
Medium: Preliminary pencil drawing, inked, and transferred to woodblock engraving.

Cards and Alice painting the roses red

TOP: Visual development study. Artist: Mary Blair. Medium: Gouache.

ABOVE: Three final frames

medium of animation. "It is not easy, technically, to turn book illustrations into animated cartoons, and the crosshatched etchings of Tenniel could not be animated just as they are," Walt explained. "They had to be redone in clean pen line and in the brilliant hues Technicolor can reproduce. They had to seem round, not flat. They had to be made mobile by the illusionary processes of animation. They had to be seen in a lifelike flow of action from various angles."

According to Walt, it was practically starting from scratch. "For the cartoon medium, the characters virtually had to be reborn, since their behavior would have to be conveyed in movement rather than with words and pen-and-ink drawings. But because the characters are so well fixed in the public mind, we could not tamper with them too much," he added. "And yet, I think we have managed to follow Tenniel in such close detail no one can say our delineations distort the images Carroll and Tenniel worked out together."

Walt gave Alice, Wonderland, and its inhabitants a Disney-style makeover—a process dubbed "Disneyfying"—with his concept artists and animators coming up with their own takes on the various characters that were close enough to the originals to be identifiable, but distinct enough to be recognized as Disney creations. Beaumont's Alice, for instance, had to be sweet, innocent, and naive—especially since she encounters so many grumpy and nonsensical characters; but she also had to be a real girl. "Alice was our most difficult character, because she was a human being. We could not take the liberties with her [that] we did with the animals,"

An Illustrated Journey Through Time

explained Walt. "The features of our Alice are somewhat more youthful than those of the Victorian maid depicted by [Tenniel]. We made her figure less stubby. Her hair is more kempt in our portrait. Though her costume is little changed, the stockings on our Alice are plain instead of striped, in order to save time devoted to drawing and for reasons related to Technicolor."

As for the rest of Wonderland's characters, Walt's artists were far less concerned with realism than Tenniel had ever been. "We made the features of the Walrus more human," said Walt. "Our March Hare is more human-esque, and so is our White Rabbit. Because he was always late and worrying, we conceived of him as an old fussbudget and developed his character along that line." But despite the design differences, Walt was, at the time, keen to reassure Lewis Carroll devotees that he had "not changed the essential meaning and mood of the book or of the Tenniel illustrations."

March Hare calling out the "mad watch." **LEFT:** Cleanup animation drawing. Artist: Cliff Nordberg. Medium: Graphite. **ABOVE:** Final frame

Walrus from 1951's *Alice in Wonderland*. **BOTTOM LEFT:** Model sheet. Artist: Disney Studio artist. Medium: Graphite. **BELOW:** Don Barclay in live-action reference footage. **BOTTOM RIGHT:** Final frame

83

Visual development study of Alice. Artist: Mary Blair. Medium: Gouache and watercolor.

An Illustrated Journey Through Time

TOP: Concept for tea party scene. Artist: Mary Blair. Medium: Gouache.

ABOVE: Concept for the White Rabbit entering the doors to Wonderland. Artist: Mary Blair. Medium: Gouache.

RIGHT: Blair reviewing visual development art for *Cinderella*

WHEN it came to the overall design of Walt's Wonderland, the contributions of designer Mary Blair cannot be overstated. An avant-garde artist working as a conceptual designer and background artist, Blair first came to Walt's attention with her concept paintings for Disney's South American-focused features, *The Three Caballeros* and *Saludos Amigos*, in the early and mid-1940s. Describing her job as "working with the writers and helping to create the ideas of the picture graphically right from the beginning," Blair worked for the studio for almost thirty years on films and theme parks, influencing the look and feel of many of Disney's post-World War II pictures, from *Cinderella* to *Peter Pan*. Animator Marc Davis puts Blair's use of color on a par with Henri Matisse. "She brought modern art to Walt in a way no one else did. He was so excited about her work."

85

Alice in a tree with her cat, Dinah, while Alice's older sister reads a book below them

TOP: **Kathryn Beaumont (Alice) and Heather Angel (Alice's sister) in live-action reference footage**

CENTER AND ABOVE: **Two final frames**

Visual development study.
Artist: Mary Blair. Medium: Gouache.

"Alice in Wonderland presented the most formidable problems we have ever faced in translating a literary classic into the cartoon medium."

— WALT DISNEY

For *Alice*, Blair produced a huge amount of concept paintings and color palettes, which pushed the film's design in a more modernist direction. Her bold use of color was in stark contrast to the subdued pastel shades of *Dumbo* and *Bambi*, Disney films from the early 1940s. Inspired by Tenniel's black-and-white illustrations, Blair envisioned Wonderland as a dark, psychological dreamscape, noting that while "Walt would not let us go completely in that direction . . . we did incorporate some pure black, white, and gray line details in the backgrounds." Her designs for Tulgey Wood, the Garden of Live Flowers (which included crabgrass made from crabs), and the Tea Party sequence were all bathed in deep shadow, with characters mainly positioned in pools of light.

But while Blair's arresting color schemes and stylized graphics proved hugely influential to the animators in terms of backgrounds, lighting ideas, and costume designs, her concepts were considered by some to be outside the studio's more mainstream animation style and tricky to adapt directly to the big screen. "If you moved Mary Blair's things, the question is whether it would be as wonderful as it is static," revealed Disney art director Ken Anderson. And yet Blair's sensibility is present throughout *Alice*, from leaf patterns to backgrounds, characters to props, and from the design of the White Rabbit's house to the classic Painting the Roses Red sequence. The March of the Cards sequence, too, originated in her small concept paintings and, as animated by Judge Whitaker, it remains one of the film's most dynamic moments.

Queen of Hearts and her army of cards

ABOVE AND OPPOSITE, TOP: Visual development studies. Artist: Mary Blair. Medium: Gouache, graphite.

OPPOSITE, CENTER: Further visual development studies. Artist: Mary Blair. Medium: Gouache.

OPPOSITE, BOTTOM: Two resulting final frames

OPPOSITE, BOTTOM LEFT: **Visual development study. Artist: Mary Blair. Medium: Gouache.**

OPPOSITE, BOTTOM RIGHT: **Two flower character studies. Artist: Disney Studio artist. Medium: Pastel.**

Alice in the Garden of Live Flowers

ABOVE AND RIGHT: **Visual development studies. Artist: Mary Blair. Medium: Gouache.**

BELOW AND OPPOSITE, TOP AND CENTER: **Five resulting final frames**

Mad Hatter character study from 1951's *Alice in Wonderland*. Artist: Mary Blair. Medium: Gouache.

Walt Disney's Alice in Wonderland

PARKS

"All in the Golden Afternoon"
Le Labyrinth d'Alice *(or Alice's Curious Labyrinth)*

PAGES 94–97: **Artwork and photographs depicting the development and realization of** *Le Labyrinth d'Alice*, **a hedge maze attraction, at Disneyland Paris**

94

An Illustrated Journey Through Time

95

POP-UP QUEEN OF HEARTS
W/AUDIO TRACK "OFF
WITH THEIR HEADS"

ABOVE: As Alice escapes, her body and various rocks cast Dalí-esque shadows in this final frame.

BELOW: Character development studies of the Cheshire Cat, with a sense of surrealism. Artist: Disney Studio artist. Medium: pastel.

Another artistic influence on *Alice in Wonderland* was Spanish surrealist Salvador Dalí, who had come to Walt's attention in 1944 when he saw a book on the artist in animator Marc Davis's office. Later, Walt invited Dalí (whose art clearly had an effect on 1936's *Thru the Mirror*) to make a movie for the studio. But while Dalí's planned project for the studio (right after World War II ended), *Destino*, didn't materialize, his artistic impact can be seen in *Alice*, notably in a scene where Alice runs across a barren landscape dotted with shadows, which are long and thin in his unique style.

More than 750 artists—including thirty-two animators, 102 assistant animators, 167 in-betweeners, twenty layout artists, twenty background artists, sixty-five special effects animators, and 158 inkers and painters—worked on *Alice in Wonderland* across a three-year period (1949–1951), using one thousand different shades of watercolor and producing more than seven hundred thousand drawings. Given that the project was the culmination of Walt's long-cherished dream, most of the studio's top animators were involved. And because the story was so episodic, Walt divided responsibility among three directors—Clyde Geronimi, Hamilton Luske, and Wilfred Jackson—and ten different animation directors, including the famed Nine Old Men of Disney animation: Milt Kahl, Frank Thomas, Eric Larson, John Lounsbery,

March Hare pours a cup, saucer, tea, and sugar cubes from a teapot in these final frames from the overtly surrealistic tea party scene.

Walt Disney's Alice in Wonderland

Ollie Johnston, Wolfgang Reitherman, Marc Davis, Les Clark, and Ward Kimball. Each one of the Nine Old Men competed to create the craziest comedy sequence, giving *Alice* a disjointed feeling and, according to Walt, "the tempo of a three-ring circus."

On a more practical level, that meant the design of the lead character varied slightly from sequence to sequence. "Milt [Kahl] developed the character of Alice," revealed Clark who animated the scenes in the White Rabbit's house in which she grows and shrinks, destroying the home, under the direction of Reitherman. Davis and Kahl, long considered two of the best at animating the human figure, were primarily responsible for Alice: Kahl's skills were never more evident than in the scene where Alice wrestles a flamingo, which remains a stunning example of complex staging and both broad and subtle humor.

"[I] always got stuck animating the girls," Davis noted, complaining that, as a result, he never handled any of the fun characters to animate. Johnston, too, animated Alice, but struggled with the "restrictive type of drawing required," as Davis phrased it. "Everybody knows what a real girl looks like. If you get the eyes off a little, or the nose, it really spoils the look."

ABOVE: Walt's Nine Old Men in a Disney Studio screening room. BELOW: Alice wrestles a flamingo in three final frames. BELOW RIGHT: Cleanup animation drawing from a scene by Milt Kahl. Medium: Graphite, colored pencil.

100

An Illustrated Journey Through Time

Larson, another master of character animation, directed the sequences involving Alice and the haughty, hookah-smoking caterpillar, whose look, many at the studio felt, amounted to a self-caricature. Thomas, meanwhile, was responsible for the talking Door Knob, as well as the belligerent Queen of Hearts, a slapstick cartoon villain with few subtleties and even less personality, so much so that the animator told Walt: "There's nothing for her to do to convey any of this stuff. Give me some business, and I'll give you a character." To which Walt replied: "Give me a character, and I'll give you some business."

It was Kimball who got all the fun, "mad" stuff to animate, his comedic genius readily apparent in the sequences involving the waddling Tweedles, the surrealism of the Walrus and the Carpenter, the Marx Brothers–inspired anarchy of the Tea Party, or the purple-striped Cheshire Cat who remains the maddest of the lot and was, in Kimball's words, "a masterpiece of understatement," disappearing stripe by stripe and leaving behind only a crescent moon–shaped grin. "I learned a big lesson," wrote Kimball in 1977 of the cat he had envisioned. "Actions that are supposed to be violently crazy are sometimes not as mad as more subtle, underplayed treatments."

ABOVE: Queen of Hearts cleanup animation drawing. Artist: Frank Thomas. Medium: Graphite, colored pencil.

BELOW LEFT: Cheshire Cat painted cel. Artist: Disney Studio artists. Medium: Acrylic, gouache.

BELOW RIGHT: The Cheshire Cat gradually disappears in two final frames.

Walt Disney's Alice in Wonderland

RIGHT: Cleanup animation drawing of the March Hare and Mad Hatter from 1951's *Alice in Wonderland*. Artist: Cliff Nordberg. Medium: Colored pencil, graphite.

ABOVE: The corresponding final frame

BELOW: Cleanup animation drawing of the White Rabbit reading Alice's accused crimes during her trial. Artist: Marvin Woodward. Medium: Colored pencil, graphite.

RIGHT: Final frame from the trial scene

According to Kahl, Walt had a special knack for inspiring his animators. "When we first started on *Alice*, I was working on a particular character and after hundreds of drawings I came up with something I thought was pretty good. So I took in a finished sketch and showed it to Walt." Kahl didn't get back the most positive reaction. "He wrinkled his nose. 'No, no,' he told me, 'the forehead is too big, and the body is too long, the face is too puckered, and he doesn't have enough hair. It's a stock character.'

"Whenever Walt didn't like something, he called it 'stock,' which was like saying it was ordinary," recounted Kahl. "After I reworked the character a dozen times, he finally accepted it. And he did it with a minimum of praise. He was more interested in inspiring us than in praising us. Walt was an amazing guy. He knew how to handle us."

OPPOSITE: Cleanup animation drawings of Tweedledee and Tweedledum's dance. Artist: Ward Kimball. Medium: Graphite.

TOP: Visual development studies of the tea party. Artist: Mary Blair. Medium: Gouache.

ABOVE: Resulting final frame

THE premiere of *Alice in Wonderland* took place in London's Leicester Square on July 26, 1951. In the United States, however, it opened in cinemas just two days after another *Alice* movie—one directed by Frenchman Lou Bunin—premiered (despite Walt's best attempt to obtain a court injunction to delay that movie's distribution). The critical reaction to *Alice in Wonderland* was mixed at best—and savage at worst. In Great Britain, die-hard Lewis Carroll devotees, together with British film and literary critics, accused Disney of "Americanizing" a great work of English literature. William Whitebait in the *New Statesman* complained, "This million-pound ineptitude deserves nothing but boos, and I wish cinema audiences were in the habit of according them."

Even in the United States, the film was not immune to critical censure. "In Mr. Disney's *Alice* there is a blind incapacity to understand that a literary masterwork cannot be improved by the introduction of shiny little tunes and touches more suited to a flea circus than to a major

An Illustrated Journey Through Time

LEFT AND BELOW: Visual development studies of the tea party. Artist: Mary Blair. Medium: Gouache. **ABOVE AND BOTTOM:** Resulting final frames

imaginative effort," dismissed *The New Yorker*. "Possibly nobody is going to create a visualization of Alice that won't do violence to the nostalgic imagery of the piece that remains in the mind's eye of those who grew up on Tenniel's illustrations. But even granting a certain latitude for variations in approach [, the film is] a dreadful mockery of the classic."

Less harsh was Bosley Crowther, who in his *New York Times* review, dated July 30, 1951, stated:

> Merit as visual entertainment does not necessarily mean virtue (or even propriety) as a translation of a classic of literature. . . . Mr. Disney has plunged into those works, which have rapturously charmed the imaginations of generations of kids, has snatched favorite characters from them, whipped them up as colorful cartoons, thrown them together willy-nilly with small regard for sequences of episodes, expanded and worked up new business, scattered a batch of songs throughout, and brought it all forth in Technicolor as a whopping-big Disney cartoon. Alice, for instance, is not the modest and plain-faced little English girl of Mr Carroll's suggestion and of Sir John Tenniel's illustrations for the books. She is a rosy-cheeked, ruby-lipped darling right off Mr. Disney's drawing board, a sister of Snow White, Cinderella, and all the fairy tale princesses. But if you are not too particular about the images of Carroll and Tenniel, if you are high on Disney whimsy, and if you'll take a somewhat slow, uneven pace, you should find this picture entertaining. . . . A few of the episodes are dandy . . . the music is tuneful and sugary, and the color is excellent. Watching this picture is something like nibbling those wafers that Alice eats.

> "When you deal with such a popular classic, you're laying yourself wide open to critics."
>
> — WALT DISNEY

Walt claimed to not be surprised by the critical reception. "When you deal with such a popular classic, you're laying yourself wide open to critics," he noted at the time of the movie's release, insisting that his *Alice* was designed for family audiences, not critics.

But audiences, too, were just as ambivalent, many feeling Disney had failed to do justice to the source material, with an animated film unable to capture the surreal mood and intellectual humor of Carroll's story. Part of the problem was laid at *Alice*'s free-form narrative. Even Kimball claimed the decision to allow ten different animating directors free reign was counterproductive, stating, in Leonard Maltin's book *The Disney Films*, that the film, "degenerated into a loud-mouthed [sic] vaudeville show. There's no denying there are many charming bits in our *Alice*, but it lacks warmth and overall story glue. *Alice* suffered from too many cooks—directors. Here was a case of each trying to top the other guy and make his sequences the biggest and craziest in the show. This had a self-cancelling effect on the final product."

This perceived lack of warmth became a familiar refrain. Audiences had trouble relating to Alice the way they'd related to other Disney heroes, finding her constant irritation with those she meets in Wonderland off-putting. Conventional wisdom states that when a main

ABOVE: The once-Caterpillar, now transformed into a butterfly, yells at Alice in this final frame.

BELOW: Visual development study. Artist: Mary Blair. Medium: Gouache.

An Illustrated Journey Through Time

character is constantly frustrated, so too is the viewer. And that seemed to be the case here. "Most of the characters Alice met in Wonderland were rude or dangerous, and all of them caused her some kind of trouble," Thomas and Johnston were quoted as observing in Jason Surrell's *Screenplay by Disney*. "But her reaction to them was annoyance and exasperation rather than the fear we expected from the victims of our villains." Criticism was even leveled by Walt himself. Years later, Walt blamed the movie's "failure" to connect with a wider audience on a "lack of heart," a lead character "who wasn't sympathetic," and the fact that it was "filled with weird characters you couldn't get on with."

The final cost of Disney's descent into Wonderland was a reputed $4 million and, according to Walt, *Alice* was the most difficult film he'd ever attempted. Given the project's long development, it was a shame, then, that the opening title cards misspelled Lewis Carroll's name as "Carrol," while also incorrectly noting that one of the books on which the film was based was titled "*The Adventures of Alice in Wonderland*," not *Alice's Adventures in Wonderland*.

In the end, the film earned an estimated $2.4 million on its initial release at the U.S. box office. Although not a complete disaster, *Alice in Wonderland* was never rereleased theatrically while Walt was still alive, though it aired as the second episode of the *Disneyland* TV series on ABC in 1954. In that broadcast, it was cut down from its original running time of seventy-five minutes to less than an hour; thereafter, it would occasionally run on network television, but only in that form.

Then, almost two decades later, *Alice* finally found herself in tune with the times. In 1968, following the North American release of the Beatles' animated *Yellow Submarine*, and as a result of Mary Blair's artistic legacy and the books' long-standing association with drug culture, *Alice* became a counterculture hit, screening often for stoned students on college campuses nationwide alongside *Fantasia* and *The Three Caballeros*.

Needless to say, The Walt Disney Company resisted this particular association, and withdrew prints from colleges. But then, in 1974, *Alice in Wonderland* was given its first theatrical rerelease on a double bill with *Fantasia* followed by another *Alice* release in 1981, by which time the initial critical consensus on *Alice in Wonderland* had begun to be reevaluated.

TOP: Background painting of the Queen of Hearts's hedge maze and castle. Artist: Disney Studio artists. Medium: Gouache.

ABOVE: The resulting final frame with the army of cards

TELEVISION AND OTHER FILMS
"AEIOU (The Caterpillar Song)"
One Hour in Wonderland

First aired on NBC on Christmas Day 1950, this one-hour special was Disney's first television foray with Walt himself playing host. The show featured clips from *Snow White and the Seven Dwarfs* and the Mickey Mouse 1937 short *Clock Cleaners*, as well as contributions from studio guests Edgar Bergen and Bobby Driscoll; Walt's daughters, Diane and Sharon; and *Snow White and the Seven Dwarfs*' Magic Mirror (with Hans Conried replacing the character's original voice actor, Moroni Olsen). The show was crafted mainly as a promo for the upcoming *Alice in Wonderland*, with Kathryn Beaumont, dressed in Alice's pinafore, taking a starring role. In addition to a rough flip-book–style snippet of the Tweedles dancing, the big selling point was an extended clip of the Un-birthday sequence—debuting more than six months before the film was released.

ABOVE: **Behind-the-scenes photo from *One Hour in Wonderland*, featuring Walt and Kathryn Beaumont (dressed as Alice)**

ABOVE: **Conried is shown testing makeup for the special, *One Hour in Wonderland*.**

RIGHT: **Final frame from the special in which Hans Conried played the slave in the Magic Mirror**

BELOW: **Cels and background painting from a collection of *Alice*-themed Hudson car commercials that aired soon after 1951's *Alice in Wonderland* release. Artist: Disney Studio artist. Medium: Acrylic, gouache.**

Alice in Wonderland Jell-O Commercial

Alice, the Gryphon, and Mock the Turtle starred in this mid-1950s television ad for Jell-O in which we were reliably informed that "when it comes to entertaining, there's nothing quite like Jell-O. . . . It's so bright, so colorful, it's like something out of Wonderland."

Alice in Wonderland Hudson Car Commercial

An animated Alice and White Rabbit appeared briefly in a television commercial that espoused the "deep coil spring suspension" available in the 1955 model Hudson Hornet or Wasp.

Alice in Wonderland: A Lesson in Appreciating Differences

Released in September 1978, this educational film stressed that appreciating others for their differences is an important quality in mature young people. The short also included the discarded "Beware the Jabberwock" sequence from the 1951 animated *Alice*.

Writing Magic: With Figment and Alice in Wonderland

Part of the EPCOT Educational Media Collection, this sixteen-minute educational film featured the imaginary purple dragon, Figment, from the Journey into Imagination pavilion, as well as characters from the 1951 animated *Alice in Wonderland*. It was released August 1989 and centered on the fact that brainstorming, writing, and rewriting were the keys to solving Alice's dilemma.

Walt Disney's Alice in Wonderland

PARKS

"How D'Ye Do and Shake Hands"
Alice in Wonderland Themed Areas

A collection of *Alice*-inspired moments from Disneyland Resort

CLOCKWISE FROM TOP LEFT: Concept for an unrealized *Alice*-themed segment in the original World of Color nighttime water-and-projection show that premiered in June 2010 at Disney California Adventure; a Caterpillar float from Walt Disney's Parade of Dreams that debuted in May 2005 as part of Disneyland's fiftieth anniversary; quintessential walk-around characters Tweedledee and Tweedledum bringing out the "young at heart" in Guests of all ages; stylized versions of Alice and the White Rabbit, which were added to the "it's a small world" attraction in 2009; and Alice and Mad Hatter walk-around characters helping a young Guest adjust his top hat

An Illustrated Journey Through Time

A collection of *Alice*-inspired moments from Walt Disney World Resort

COUNTERCLOCKWISE FROM TOP LEFT: A tea party-themed, water play area for kids at Disney's Grand Floridian Resort & Spa that opened September 2012; *Alice*-themed segment within the Mickey Mouse Revue, a Magic Kingdom Audio-Animatronics musical show that ran from October 1971 through September 1980; the Wonderland Cafe opened as an Internet café featuring the Cheshire Cat when DisneyQuest opened at Downtown Disney West Side in 1998 and closed in 2016; an Alice sculpture on display when the first World of Disney store opened at Downtown Disney Marketplace in October 1996; playful walk-around characters Alice and the White Rabbit in front of the Magic Kingdom's Mad Tea Party attraction

111

Walt Disney's Alice in Wonderland

ABOVE: Visual development of Alice first sitting down at the tea party from 1951's *Alice in Wonderland*. Artist: Mary Blair. Medium: Gouache.

RIGHT: The resulting final frame

OPPOSITE: The Dormouse surprises Alice by popping out of some fireworks and reciting "twinkle, twinkle little bat" before floating down into his teapot.

TOP LEFT, CENTER RIGHT, AND BOTTOM LEFT: Three final frames

TOP RIGHT: Visual development. Artist: Disney Studio artist. Medium: Graphite, ink, watercolor.

CENTER LEFT: Model sheet. Artist: Disney Studio artist. Medium: Graphite.

BOTTOM RIGHT: Story sketch. Artist: Disney Studio artist. Medium: Graphite.

Today, *Alice in Wonderland* is considered a Disney classic and one of the studio's most popular animated movies. Its depiction of Carroll's iconic characters has become part of the collective conscious. Its influence is felt in all forms of popular culture, not least in Disney's theme parks worldwide where it's even the basis for several long-running attractions and themed areas. In fact, it remains the only Disney film to have two attractions devoted to it within Disneyland Park.

James Bobin, director of *Alice Through the Looking Glass* (2016), the sequel to the 2010 Disney live-action *Alice in Wonderland*, expresses a sentiment shared by hundreds of thousands in contemporary culture of the 1951 animated film: "It's amazing, it's beautiful. For many people, *that* is still the Alice they know and love more than any other—even more than the book. I mean, the book is only really read by kids these days in a very abridged form; but most people know about Alice as the girl in the white [apron] and blue dress. It's a significant contribution to the canon of the work of *Alice*."

SHORTS

"Very Good Advice"

Donald in Mathmagic Land

A pith helmet–wearing Donald Duck follows a numbered trail into a wonderland of mathematics and embarks on a geometrical journey where, via a trip to Ancient Greece, he learns about the secrets of the golden rectangle and the pentagram, as well as the fact that "all nature's works have a mathematical logic." Mixing animation (with *Alice in Wonderland*'s Wolfgang Reitherman and Les Clark acting as sequence directors under supervising director Hamilton S. Luske) and live action, this delightful educational twenty-eight-minute short was released in 1959 in theaters with *Darby O'Gill and the Little People* and nominated for an Academy Award. It also features several Salvador Dalí-inspired cartoon sequences, as well as Donald transforming into a Lewis Carroll-style Alice, who grows in size after taking a bite of a cookie, before facing off against a hostile Red Queen chess piece on a giant chessboard.

ABOVE: As with 1951's *Alice in Wonderland*, surrealism influences 1959's *Donald in Mathmagic Land* featurette directed by Hamilton S. Luske. Concept art of Mathmagic Land. Artist: Disney Studio artist. Medium: Gouache. LEFT: Final frame of a creature that could easily fit in at Tulgey Wood. RIGHT: Final frame of Donald against an ancient Greek background with Salvador Dalí-esque shadows

An Illustrated Journey Through Time

TOP, ABOVE, AND BELOW: **To teach about math within the game of chess, the Spirit of Adventure magically dresses Donald in an Alice-inspired outfit and shrinks him to the size of a pawn. Concept illustrations. Artist: Disney Studio artist. Medium: Gouache.** LEFT: **Cleanup animation drawings. Artist: Bob Youngquist. Medium: Colored pencil, graphite.**

115

Walt Disney's Alice in Wonderland

THIS SPREAD AND PAGE 118: In these final frames, after Donald escapes a cranky red queen and knight, he finds an inviting box of candy. Upon eating a piece, Donald naturally grows bigger.

116

An Illustrated Journey Through Time

THIS PAGE: **Again finding inspiration from surrealist art, the finale of 1959's *Donald in Mathmagic Land* brings Donald to all the doors that have been opened by mathematical thinking and new discoveries—as well as all the (for now locked) doors of the future—before the scene dissolves into a swirl of pentagram shapes.**

119

3
Curiouser & Curiouser

The Live-Action Adventures

IN THE YEARS following Walt's animated *Alice in Wonderland*, Carroll's tale continued to be adapted for film and television, be it Jonathan Miller's acclaimed 1966 BBC version starring Anne-Marie Mallik, or Jan Svankmajer's 1988 surrealist combination of live-action and stop-motion, *Alice*, to 2009's contemporary spin, *Malice in Wonderland*, which is set in northeastern England.

Linda Woolverton, screenwriter of Disney's *Beauty and the Beast* (1991) and *The Lion King* (1994), had toyed with the idea of reimagining *Alice* for a number of years. "I had been running at it in a lot of different ways in my head, [but] I did not have an answer until I figured out to age her up and bring her back," she revealed.

Given the "hubris" Woolverton said was required to reconceive Carroll's classic, she was more than a little fearful about tampering with both text and characters when stepping into the role of screenwriter for Disney's 2010 live-action *Alice in Wonderland*. "It had to be outside the canon for me to be able to do what I wanted," she admitted. "I felt the whole time I needed to honor the work, but also take those incredible characters and make them into a tale that is accessible to a modern audience. There's no way I could have done that, adapting the material as it exists. But to go out of it and bring her back, in a different way, it still leaves the beauty and perfection of the [original] work intact."

What finally gave Woolverton the freedom to begin was a mental image she had of Alice standing by a rabbit hole when, suddenly, a little white rabbit paw pops out, grabs her by the ankle, and jerks her inside. "That was a very crucial image for me," she reflects. "It wasn't a voluntary act of going down; it was her being brought back for a reason, against her will." Moreover, the Alice she saw in her mind's eye wasn't the little girl of Carroll's tales; rather, she was a young woman, nineteen years old, on the cusp of adulthood.

ABOVE: A 1951 poster for the initial release of the animated *Alice in Wonderland*

LEFT: Linda Woolverton, screenwriter

BELOW: Mia Wasikowska's Alice wanders the grounds of the garden party and stumbles upon a number of curious moments at the beginning of Tim Burton's 2010 *Alice in Wonderland*.

OPPOSITE: Johnny Depp as Burton's Mad Hatter

An Illustrated Journey Through Time

This teenage Alice had journeyed to Wonderland as a child, but now has no real memory of it, apart from as a recurring dream. She's strong-willed and feisty, much like Carroll's Alice is, but had lost what the book refers to as her "muchness" in recent years, not least since the death of her beloved father. "She's broken," Woolverton said. "There's an empty hole on the inside, and it takes her going back to regain that spark she had as a child; it takes going back to Wonderland to get her 'muchness' back, to get her courage and her strength."

"What I liked about this take on the story is Alice is at an age where you're between a kid and an adult, when you're crossing over from one thing to another, as a person," said Tim Burton, director of *Charlie and the Chocolate Factory*, *Batman*, and *Frankenweenie*, who was hired by Disney to helm Woolverton's script. "Alice is somebody who doesn't quite fit into that Victorian structure and society; she's more internal."

Young women growing up in Victorian England were expected to marry and have children, not to work, nor to question their place in the world. But Woolverton's Alice dreams of a life on her terms, a life spent visiting faraway lands, doing what she wants, when she wants, unbeholden to any man. Although, at first, Alice doesn't really know exactly what it is she wants, only that it's not to be married and not to settle for convention. "It's a very teenage moment," mused Woolverton. "What are you going to do with your life? Who you going to be? I really wanted it to resonate with teenagers, and, I guess, my daughter."

Another inspiration for the Burton-directed film was a John Tenniel illustration for Carroll's poem, "Jabberwocky," which appeared in *Through the Looking-Glass, and What Alice Found There* and featured a boy holding a sword. Only Woolverton didn't see it as a boy. She saw it as Alice, wielding the Vorpal Sword, killing the Jabberwock. Suddenly, Alice's destiny, the end of her journey, was laid out for her. "That one illustration really drove me, about where I was going to take her," Woolverton noted. "This Victorian girl in her little blue dress will, ultimately, stand there in armor, holding the Vorpal Sword, and slay that creature. And I have to get her from here to there. And isn't that going to be interesting."

While the story Woolverton eventually hatched used characters, themes, and situations familiar from both *Alice's Adventures in Wonderland* and *Through the Looking-Glass*, as well as the "Jabberwocky" poem, it was, for all intents and purposes, a sequel to Carroll's work. (The only entirely new characters added to the 2010 movie were a hound voiced by Timothy Spall named Bayard, who helps the heroine and his

BELOW: Alice peers down the rabbit hole in 2010's *Alice in Wonderland*.

ABOVE: Near the film's climax, Mia Wasikowska's Alice prepares to face the fearsome Jabberwocky.

OPPOSITE: The "Jabberwocky" poem illustration from Lewis Carroll's *Through the Looking-Glass*, 1871 edition, that inspired screenwriter Linda Woolverton for the film's climatic scene. Artist: Sir John Tenniel. Medium: Preliminary pencil drawing, inked, and transferred to woodblock engraving.

TOP: Anne Hathaway's White Queen greets Bayard the bloodhound.

ABOVE: The Stephen Fry-voiced Cheshire Cat

wife and pups.) "It falls somewhere in between an adaptation and a retelling," said Anne Hathaway, who played Mirana, the White Queen in the film. "If the first book was about Alice exploring her imagination, this is about Alice finding her soul."

But it first begins with Alice as the young girl from Carroll's tale, before picking up with Alice (Mia Wasikowska), now nineteen, heading to a garden party with her mother, Helen (Lindsay Duncan), at the Ascot Mansion, a party that, unbeknownst to her, will double as her engagement soiree. But, after an awkward and very public proposal from young Hamish Ascot (Leo Bill), Alice rushes off, giving chase to a waistcoat-wearing, clock-watching White Rabbit, and then follows him down into a rabbit hole to Wonderland (or Underland as its inhabitants call it).

The place of her dreams is, however, in chaos and disarray under the rule of Iracebeth, the tyrannical Red Queen (Helena Bonham Carter), a frightening amalgamation of the Queen of Hearts from *Alice's Adventures in Wonderland* and the Red Queen from *Through the Looking-Glass*, and a spoiled, spiteful monarch with an oversized head, which, Woolverton decided, was the result of a tumor: "It almost gave her an excuse for her

An Illustrated Journey Through Time

ABOVE: Helena Bonham Carter's Red Queen quizzes her frog footmen over who ate the tarts.

BELOW: Mia Wasikowska's Alice battles the Jabberwocky.

behavior. She's got something growing in there, pressing on her brain."

Alice has been brought back for a purpose—"The world is broken," continued Woolverton, "and they need her to fix it," namely by slaying the Red Queen's champion, the dreaded Jabberwocky, on Frabjous Day, thus bringing about the end of her reign, an event foretold in the Oraculum, an illustrated scroll that reveals the history and future of Underland.

To play his Alice, Burton cast Wasikowska, an Australian actress, who was then nineteen years old (just as Alice is in this film), after a worldwide search. "She had a quality that surprised me," he recalled, "a kind of emotional toughness, emotionally standing her ground in a way that makes her kind of an older person but with a younger person's mentality. She's somebody who's very secure in herself at a certain level. And

yet she had that quality I always find artistic people have, where they're very intelligent but also have a certain naivety about them."

The responsibility of being cast as a character as beloved and known as Alice brought many conflicting emotions, according to Wasikowska. "It's amazing and so exciting, but there's a lot of pressure, because everyone has their idea of Alice. Everyone thinks they know who she is, and you can't please everyone. Alice is such an iconic character. I wasn't sure at first how much they wanted to play with that or how differently they wanted to make her.

"Tim decided it was important to keep some of the iconic nature," the actress noted. "The challenge was finding Alice the teenage girl and bringing her to that story. I wanted to make her real to teenagers and young adults."

"You have to give credit to Linda because she wrote the adult Alice as a really strong character," observed James Bobin, director of *The Muppets* (2011), *Muppets Most Wanted* (2014), and the *Alice in Wonderland* sequel, *Alice Through the Looking Glass* (2016). "Alice has always been that. She's so headstrong and interesting and clever. I think Lewis Carroll was very keen to put accross the idea that young women should be listened to, do have their own opinions, and are equal to men.

"What drew me to the character as a child, and even more so in later life, as I studied nineteenth-century English politics," added Bobin, "was, if

TOP: Concept illustration of Alice in the Garden of Live Flowers from 2010's *Alice in Wonderland*. Artist: Steven Messing. Medium: Digital.

ABOVE: Alice takes a step into Underland.

An Illustrated Journey Through Time

BELOW: Two views of Johnny Depp as the Mad Hatter, from 2010's *Alice in Wonderland*—revealing Colleen Atwood's remarkable costume design, as well as the green contacts and postproduction digital work to enhance the character's eyes

you think about Alice Liddell, who the book was based upon, her generation was very much the first to realize they should be treated as equals to men and have every right to education and to vote. Hers was the generation that became suffragettes. Lewis Carroll recognized that and wrote an interesting, clever character, and Tim [Burton, the 2010 film's director] played on that even further."

Alongside Alice, Carroll's most iconic creation is the Mad Hatter, although, ironically, he's never referred to as that in the book. The Hatter, or Hatta, first appears during the Mad Tea Party chapter in *Alice's Adventures in Wonderland*, telling Alice her hair needs cutting before asking her a riddle about a raven and a writing desk that never gets answered.

Woolverton's script reprised the tea party but added a political edge to the obvious chaos and surrealism by placing it where the resistance against the Red Queen gathered. She also furnished the Hatter with a tragic backstory, seen in flashback, when his entire family, the Hightopps, was murdered by the Jabberwocky on the orders of the Red Queen. "They all used to wear top hats, and after the Jabberwocky killed them, there was only one top hat left," Woolverton explained. "And that's the top hat he always wears. It's a little singed. But the traumatic events have really affected him."

When writing her Hatter for the 2010 movie, Woolverton had Johnny Depp in mind long before Burton boarded the project and brought the actor with him, since the pair had worked together on numerous projects in the past. Given the iconic nature of the character, it was, said Depp, "a real challenge to find something different, to define the

Walt Disney's Alice in Wonderland

ABOVE: The Mad Hatter is captured and taken to the Red Queen's throne room.

BELOW: Two promotional posters from the debut of 2010's *Alice in Wonderland*

BOTTOM RIGHT: Anne Hathaway's White Queen mixes a potion that helps a slightly oversized Alice shrink to a more comfortable height.

Mad Hatter in terms of cinema." In his research, Depp discovered that the term "mad as a hatter" was derived from the fact that the glue hatters of the period used to make beaver-pelt top hats had a very high mercury content. "It would stain their hands, and they'd go goofy from the mercury," said the actor, who felt his character's entire body, not just his mind, would have been affected by the mercury, turning his hair orange, his eyes green, and face white. Depp put his ideas down in several watercolor paintings and worked with Burton, makeup artist Joel Harlow, and costume designer Colleen Atwood to bring the character to life. On the set, Depp wore green lenses, while in postproduction Burton used digital effects to increase the size of the Hatter's eyes and enhance his clothes to further reflect his mood swings. Depp's Hatter, too, had different accents to reflect his various personalities, switching between English and Scottish depending on the character's temperament.

To rid Underland of the Red Queen, Alice joins forces with Iracebeth's sister, the White Queen, who, despite the name, was played with more than a hint of darkness by Anne Hathaway. "She comes from the same gene pool as the Red Queen," Hathaway explained. "My character really likes the idea of violence, really likes weapons, really likes the dark side. But she's so scared of going too far into it she's made everything appear very light and happy. She's living in that place out of fear that she won't be able to control herself."

In developing the character, Hathaway decided the White Queen had never gotten along with her sister. "The Red Queen rubs her the wrong way," she remarked. "They're not buddies. They're just related."

DESPITE the multitude of *Alice* adaptations, few have managed to create a Wonderland worthy of its name. Having started his career as an artist in the Animation Department at the Disney Studios in the late 1970s, Burton has, in the years since, proved himself to be one of cinema's true visionaries. His unique design sense, bold stylings, and ability to create entire worlds on-screen made him perfectly suited to reinterpret Carroll's world for the big screen. "He was the right person to bring this material to life, because as cool as *Alice* is, it needed to be reinvented," said producer Jennifer Todd. "I don't think anyone was really interested in seeing a little girl in a blue and white dress. Tim's created a whole new world for Alice to live in."

Shortly before he began work on *Alice*, Burton bought a house in London to use as an office—a house that had once been the home of Arthur Rackham, one of the most celebrated *Alice* illustrators, who had drawn his version of Carroll's story right there. "I found it very inspiring as we began creating the characters," said Burton, whose plan for Wonderland was to "make it classic but also make it look new."

ABOVE: Concept illustration of the mushroom forest, from 2010's *Alice in Wonderland*. Artist: Steven Messing. Medium: Digital.

BELOW LEFT: One of Arthur Rackham's illustrations for Lewis Carroll's *Alice's Adventures in Wonderland*, 1907 edition. Medium: Color plates.

BELOW: The March Hare, voiced by Paul Whitehouse

131

To begin, he and production designer Robert Stromberg (*Avatar*) went back to the source material, gathering up all the artwork from the various artists who'd drawn *Alice in Wonderland* to understand what was out there. Stromberg recalled, "Then we started talking about how we could keep it true to the book but take it to a place that hadn't been seen before."

The book's original John Tenniel illustrations lay down a strong base. "To a certain extent those became our imprint for Alice's flashbacks in the movie," noted art director Todd Cherniawsky. "Whereas what ends up happening in Wonderland is definitely a more Burton-esque version."

"Everybody's got an image of Wonderland," said Burton. "In people's minds, it's always a very bright, cartoony place, but we thought if Alice had had this adventure as a little girl and now she's going back, it's a bit overgrown. The topiaries aren't as nicely cut as they once were. Perhaps it's been a little bit depressed since she's left. It's got a slightly haunted quality to it."

The key to Wonderland's haunted look was a photograph taken during World War II of a British family having tea outside with the battered, disheveled London skyline in the background. "That started to fuel the arc of Wonderland starting out as a dark, gloomy world with a crushed palette," revealed Cherniawsky. "Then, as the film unfolds and things become more positive, we had a place to go to with the lighting and color."

TOP: Concept illustration of Alice first entering Underland, from 2010's *Alice in Wonderland*. Artist: Unknown. Medium: Digital.

ABOVE: Concept illustration of the Dodo

BELOW: Concept illustration of the tea party sequence featuring the Cheshire Cat, March Hare, Mad Hatter, and the Dormouse. Artist: Unknown. Medium: Digital.

An Illustrated Journey Through Time

Burton's original plan was to shoot *Alice* as a motion-capture film in the vein of *The Polar Express* and *Beowulf*, but he soon changed his mind. The majority of the film was, however, shot inside massive all green-screen soundstages in Los Angeles in order for Wonderland itself to be entirely computer generated. (All the sequences involving Wasikowska's Alice in the real world were shot on location in England.)

Initially, Wasikowska's Alice was to be the only live-action character in this digital Wonderland. But having cast Depp, Bonham Carter, and Hathaway, Burton decided to combine real actors, computer-generated characters (among them the White Rabbit, Dormouse, Jabberwocky, March Hare, Dodo, Bayard, and the Bandersnatch), and "hybrid" characters using a blend of motion-capture and CGI (such as Tweedledee and Tweedledum, both of whom are played by Matt Lucas, and Crispin Glover's Knave of Hearts).

What Burton was proposing hadn't, at the time, been attempted before—"In some ways we treated it more like an animated film," he said—all under the watchful eye of visual effects supervisor Ken Ralston, a multiple Oscar winner and one of the founders of George Lucas's pioneering visual effects company, Industrial Light & Magic. Moreover, Burton wanted all the live-action characters, bar Alice and the White Queen, to be digitally altered in postproduction—inflating the Red Queen's head, for starters—so as to better integrate them into Wonderland.

ABOVE: Concept illustration of the White Queen's castle, from 2010's *Alice in Wonderland*. Artist: Steven Messing. Medium: Digital.

BELOW: The live flowers, the Dodo, the Dormouse, Tweedledee and Tweedledum, and the White Rabbit all stare at Alice as she enters Underland.

133

ABOVE: Promotional poster from the debut of 2010's *Alice in Wonderland*

BELOW: Cosplayers Lori Ouellette as the Red Queen, Andrew Ouellette as little Mad Hatter, and Dan Schmidt as the Mad Hatter. Photography by Joey Jones; costumes by Dan Schmidt based on designs by Colleen Atwood

RIGHT: Costume/character sketch for the Red Queen

OPPOSITE: The Red Queen during a game of croquet with flamingo mallets, from 2010's *Alice in Wonderland*

The results were spectacular. Released in March 2010, *Alice in Wonderland* proved to be a massive hit, with global box office takings in excess of a billion dollars, making it Burton's most successful film to date, winning Oscars for Atwood (for costume design) and Stromberg (for art direction).

Almost immediately, the new and distinctive look of Depp's Hatter and Bonham Carter's Red Queen started showing up on the cosplay circuit, as fans began dressing themselves in replicas of Atwood's amazing costumes. No longer was the 1951 Disney animated movie the default look for Carroll's creations; Burton's film had provided a new interpretation for a new generation of *Alice in Wonderland* devotees who were ready to embrace it.

"By the time the movie came out, I started seeing all these people and costumes pertaining to the job, and I realized the cult thing was really going to be huge," said Atwood. "I'm always deeply complimented when somebody takes something I've done and reinvents it for themselves and it becomes part of their social life. It's a compliment to a film, to a costume, and, of course, [to] Tim, as well as Johnny [Depp], that people really connected with them. They're fun; they make people smile. The eccentricity of the Hatter has huge appeal. But they also connected with Alice in a huge way."

Indeed, Wasikowska's feisty, determined rendering of Alice came to be seen as something of a role model for young women around the world, much to the pleasure of Woolverton, the film's screenwriter. "That was wonderful," she said. "It was gratifying for me because it was about a young girl empowering herself, and I felt I had spoken to them in a way that hopefully [will] empower them."

IRACEBETH, THE RED QUEEN

134

PARKS

"'Twas Brillig"
Mad T Party Nightly Entertainment

Introduced at Disney California Adventure in the summer of 2012, the "T" is a nightly dance party presided over by a Tim Burton *Alice in Wonderland*-inspired band. Fronted by the Mad Hatter and Alice, the band features the Dormouse (guitar), March Hare (bass), Caterpillar (keyboards), and Cheshire Cat (drums)—with a White Rabbit DJ keeping the music going between setups and the Tweedles entertaining the crowd throughout.

Around the main stage, two bars (Drink Me and House of Cards) serve *Alice*-themed drinks, while Who R U?—a caterpillar-like dance act—had worked a second stage. The show ran until winter 2014, before closing briefly for a refresh that removed the second stage and tweaked the content slightly. It reopened May 2015 for the Disneyland Resort's Diamond Celebration for Disneyland Park's sixtieth anniversary.

THIS SPREAD: Images of the Mad T Party "mayhem" at Disney California Adventure

PARKS
"Painting the Roses Red"
Alice in Wonderland Maze

Designed as an opening day attraction for Shanghai Disneyland, the Alice in Wonderland Maze is unique among Wonderland-themed attractions as it is inspired by the 2010 Tim Burton live-action film. As Guests navigate the maze, they choose their own routes through the whimsical world, with Mad Hatter's Tea Party serving as the final destination. Among the sculpted hedges, park-goers may come upon the Cheshire Cat, the White Rabbit, and sculptures of other iconic characters including the Red Queen.

ABOVE: Concept illustrations of character totems designed for the attraction. Artists: Mike Peraza, Allie Wong, Danqing Zhang, Chris Kawagiwa. Medium: Digital.

LEFT AND OPPOSITE: Concept illustrations in the form of scrolls depicting the attraction. Artists: Dermot Powers, Alisara Tareekes, Laurel Scribner, Luca Shen. Medium: Digital.

An Illustrated Journey Through Time

如果你沿着爱丽丝走过的路……

白兔的爪印将为你指引方向

一个奇妙的旅途就在前方

如果你向花儿或妙妙猫问路……

路上的陌生人——个比一个奇怪

他们可能对你没有一点帮助……

你在玫瑰丛中漫步，芳香扑鼻……

若踏上皇后的宝座，切莫大意

一对红心骑士，守在御花园门口

忠心耿耿，效力凶煞的红皇后……

如果迷失在疯帽子的迷宫里……

仙境的朋友们在期盼着你……

继续向茶会前进！事不宜迟！

IT WAS PERHAPS inevitable, given the success of Tim Burton's film, that a sequel would follow. Perhaps the only surprise was that it took this long to get the ball rolling. "We worked on the script for a very, very long time," said Suzanne Todd, producer of 2010's *Alice in Wonderland* and its sequel, *Alice Through the Looking Glass*. "We didn't want to make a sequel just because the first movie had been successful. We wanted to find themes that were interesting to us and a relevant journey for her character that would honor what we had tried to do in the first movie."

Not that Carroll's own sequel was much help. *Through the Looking-Glass, and What Alice Found There* has an even slighter plot than *Alice's Adventures in Wonderland*. "It's basically an allegory of a chess match over eight chapters, where Alice starts as a pawn and ends as queen, and which doesn't particularly lend itself to film narrative," noted James Bobin. "What I wanted to do was take the elements I enjoyed, like the backwards room and the mirror, then embellish a story, partly based on the world Tim created and the characters he and Linda [the screenwriter] created." (Burton, having handed over directorial duties to Bobin, remained attached to the project as producer.)

Woolverton began by asking herself this: what was the basic idea behind the first film? And she arrived at the words spoken by Absolem, the Caterpillar, to Alice: *Who are you?* "It is Alice *defining* herself. Not finding herself. Defining herself," Woolverton revealed. "There were a lot of questions I thought we could answer in the second movie. Why is the Red Queen's head so big? Why is she in charge and not her sister? What happened in Wonderland? A lot questions I thought people would like to know."

Her script, both a sequel and prequel to Burton's film, details Alice's journey into womanhood, and reveals exactly what happened to the Mad Hatter's family on Horunvendush Day, plus explores the childhood incident that set the White.Queen and Red Queen at odds.

OPPPOSITE: Mia Wasikowska's Alice wears a Chinese ceremonial gown and poses with the Chronosphere in a publicity shot from 2016's *Alice Through the Looking Glass*.

BELOW: Absolem, the Caterpillar, from 2010's *Alice in Wonderland*

"Who are you?"

141

ABOVE: Concept illustration of Alice in the captain's cabin of the *Wonder*, from 2016's *Alice Through the Looking Glass*. Artist: Michele Moen. Medium: Digital.

BELOW: Alice takes her first steps on English soil after three years at sea.

At the end of the first film, Alice had turned down Hamish's hand in marriage for a life on the high seas, following her father's dream to seek out new opportunities in the Far East. *Alice Through the Looking Glass* begins with Alice still at sea, and captain of the *Wonder*, battling crashing waves and pirate ships in the Straits of Malacca. She eventually returns home three years later, one more than anticipated, having met with "emperors, beggars, holy men, and pirates." But she's lost touch with her family, and her mother in particular, "in that way we do when we're out pursuing our goals and things get busy, [and] at that age where you're focused on your career and you want to get things moving ahead," explained Woolverton.

"But you're also trying to find a balance with what's important in terms of spending time with the people you love and accomplishing your goals in your professional life," Woolverton further explained.

Back in London, Alice discovers she is as out of sync as ever with Victorian society. "The Victorian era isn't necessarily suited for a woman who has a character like Alice," said Woolverton. "She's been off; she's dealt with impossible circumstances, successfully, and when she comes

142

back, she's a strong woman in a world that doesn't appreciate strong women. Thematically, that's a very contemporary theme. I loved putting the new Alice in that world and seeing what would happen. And bad things happen.

"We got to explore the idea of female hysteria; that strong, headstrong women who don't follow the rules are considered crazy," added Woolverton.

With Alice's more pronounced confidence comes a fearless comfort with herself that Wasikowska, reprising the role of Alice, admires. "She's perfectly fine wearing her traditional Chinese outfit, and she knows it makes people uncomfortable," said the actress. "It's evident she's gained a lot more confidence in her own decisions and opinions, and she doesn't let any of the characters push her around."

"Alice, in this movie, has even clearer ideas about her identity," noted Bobin. "She has a very modern sensibility about her place and what a woman should be allowed to do. Of course, Victorian society has a very different view about what that should be, and that's embodied in her mother's view of the world. Women were expected to be demure, listen and support and look after the children."

ABOVE: Alice makes a scene at the Ascots' mansion.

BELOW: Concept illustration of a harbor in England. Artist: Michele Moen. Medium: Digital.

Not that Alice has any intention of settling down, eager to be back on the high seas again. But there's a problem: the now-married Hamish, perhaps as revenge for Alice turning down his hand, has persuaded Alice's mother to sell her shares in the shipping company Alice expected to control, as well as a bond on her house. Alice thus gives up her dream and signs over her ship to redeem the family home and save her mother from poverty. In return, Hamish offers Alice a job as a suffocating deskbound clerk.

Salvation appears with Absolem, who leads Alice into a dusty, closed-off upstairs parlor of the Ascot Mansion, and through a looking glass, back into Underland, where she discovers her great friend, the Hatter (Depp) is in serious trouble. Only she can bring him back from the depths of his despair, a marked depression that has affected him mentally and physically, and taken a toll on everyone in Underland.

When Alice arrives at the Hatter's wood-framed house, which, inevitably, is shaped like a hat, she finds him deadly serious, denying himself any laughter and growing less daft by the minute—his hair combed into a severe parting, his

144

An Illustrated Journey Through Time

> "I loved the idea of the Hatter being mad, but not mad in a good way."
>
> —Linda Woolverton, screeenwriter

ABOVE: Concept illustration of the Hatter's home interior from 2016's *Alice Through the Looking Glass*. Artist: Ra Vincent. Medium: Digital.

LEFT: Alice arrives to save the Mad Hatter and his family.

OPPOSITE, TOP: Alice approaches the Looking Glass.

OPPOSITE, BOTTOM: Concept illustration of the Hatter's home exterior from 2016's *Alice Through the Looking Glass*. Artist: Anthony Allan. Medium: Digital.

clothes neatly pressed—and unable to recognize her despite their shared past. "The discovery of his past has turned him sane," revealed Bobin. "He's ill, he's wearing a gray suit, and his color is fading, because he's been consumed by an idea which seems impossible." Namely, that his family wasn't killed by the Jabberwocky on Horunvendush Day and is still alive.

"I loved the idea of the Hatter being mad, but not mad in a good way," said Woolverton. "Lost. I thought the loss of his family would be devastating for him, and if we could somehow save them by going back to the past, it would be a very heartening story."

ABOVE: Concept illustration of a flower-filled field leading to Tulgey Wood on Horunvendush Day, from 2016's *Alice Through the Looking Glass*. Artist: Anthony Allan. Medium: Digital.

BELOW: Alice with the Mad Hatter in Witzend

OPPOSITE: Johnny Depp's Mad Hatter poses with the Chronosphere in a publicity shot for 2016's *Alice Through the Looking Glass*.

Depp's Hatter was, for both Bobin and Woolverton, key to *Alice Through the Looking Glass*. The actor's original eccentric, orange-haired portrayal was so unique and so successful that for many it's become the take on that character. "It has become such an icon of the canon of Lewis Carroll's work," said Bobin. "People love that character, that's why we wanted to lean the story on him. We loved that character so much; we wanted to go into his backstory."

Hathaway (back as the White Queen) agrees. "Johnny did such a fun thing with the character in the first film. It was so entertaining and lovable and surprising, which was key to the second film working because you care about the Hatter," the actress said, "and you have to really believe that his madness adds a wonderful sense of fun and color to a world that is better for it. And when you see him suppressing that, when you see him fighting that, when you see him not being himself, it's heartbreaking."

Once back in Underland and committed to saving the Hatter, Alice regains her power. "She's a leader in this movie," Woolverton explained. "Everyone turns to her for the decision-making. She's absolutely the one in charge. And she makes mistakes, but everything she does is for love—for love of her friends, for the Hatter. But she's strong. I think the girls who liked the first movie will see she's embodied the ideals she came away from the first movie with, and went out into the world. But it's not easy, life. So that's important, too."

Alice's mere presence in Underland isn't enough to help the Hatter, however. She must travel back in time to Horunvendush Day, and beyond, using the Chronosphere, a beautifully designed clockwork device that powers time and is found at the ticking heart of the Grand Clock of All Time. "It is essentially the battery to the clock, which runs all time in Underland," revealed Bobin. Housed in Time's castle, and guarded by a mechanical regiment of Minutes, Seconds, and Hours, the Chronosphere also happens to be a time machine. But when Time, played by Sacha Baron Cohen, refuses to loan it to Alice, she decides to steal it. As the removal of the Chronosphere puts all of time at risk, a greatly upset Time sets off after Alice, across the Oceans of Time in another time machine, a wooden one called the *Tempus Fugit*.

The idea of Time being a person was, said Bobin, Lewis Carroll's. "Charles Dodgson/Lewis Carroll was very interested in the idea of mathematics and logic, and time falls into that area," the director emphasized. "When you read *Alice's Adventures in Wonderland*, when Hatter first meets Alice, he said to her, 'If you knew Time as well as I do, you wouldn't talk about wasting *it*. It's *him*. . . . We quarreled last March.' So Lewis Carroll mentioned this character you've never seen. He's an embodiment of time. People talk about him quite a lot. And I thought if Alice was going to travel in time, then it would be very nice if she had to go ask permission."

> "If you knew Time as well as I do, you wouldn't talk about wasting *it*. It's *him*. . . ."
>
> —from Lewis Carroll's *Alice's Adventures in Wonderland*

An Illustrated Journey Through Time

OPPOSITE, CENTER: Model of the Chronosphere from 2016's *Alice Through the Looking Glass*. Artist: Paul Ozzimo.

OPPOSITE, BOTTOM: Concept illustration of the clock chamber in Time's castle. Artist: Laurent Ben-Mimoun. Medium: Digital.

ABOVE: Concept illustration of the clock room in the Red Queen's castle. Artist: Unknown. Medium: Digital.

PAGES 150-151: Concept illustration of the courtyard at the Red Queen's castle. Artist: Unknown. Medium: Digital.

To Bobin's way of thinking, Time would be a "very pompous, very self-opinionated buffoon, but he has enormous power, because Time is a man who's spent a lot of time by himself over the years and so has great self-belief. But at the same time when you spend time by yourself, you end up being rather lonely."

As such, Time has entered into a relationship with the Red Queen, who was banished to the outlands of Underland at the end of the last movie and is now living in a heart-shaped castle made of roots and vegetables, waited on by a vegetable army and staff, all fashioned for her by Time as a token of his love. "He, being a deeply lonely person, has great affection for her," said Bobin. "She, of course, has no such reciprocal feelings and is purely using him for her own devices."

An Illustrated Journey Through Time

Playing such an exalted figure as Time required a larger-than-life performer; so Bobin cast British actor/comedian/writer Baron Cohen, with whom he worked early in his career on *Da Ali G Show* on TV. "Sacha is so great at playing the confident idiot. He has pantaloons and a doublet, an amazing bishop's hat, and this very elaborate, large cloak with enormous shoulders," recounted Bobin. "What I'm very pleased about is he feels very much part of the world, partly because it's Lewis Carroll's original idea, but partly because Sacha's so good at playing that kind of role. He slots right into the milieu of the Hatter, and Alice and the Red Queen."

Thematically, too, time is key, as Alice must learn, and try as she might, one can't change time. Instead, one has to learn from it. "Time we conceive as the enemy," said Woolverton. "'Time is not your friend,' her mother tells her. In the end she has come to accept the events that have happened, that her father's gone. We all have traumatic events and we have to come to peace with them."

Bobin added, "It applies to Alice's life aboveground, with her mother, and being away at sea all that time, but also to her life in Underland, trying to appreciate the people you have around you at the time they are around you."

OPPOSITE: Sacha Baron Cohen's Time poses with the Chronosphere in a publicity shot from 2016's *Alice Through the Looking Glass*.

BELOW: Time in his castle sitting room

In the case of Tarrant Hightopp, aka Depp's Hatter, that internal struggle is all about his father, Zanik (Rhys Ifans), whom he is convinced is still alive, along with the rest of the Hightopp clan. "I thought it would be interesting if the Mad Hatter had a very serious father," said Bobin. "Obviously, he's a Hightopp and he's a hatter in Underland, so he has a slightly crazy twist about him, but he is, in essence, a Victorian father to this creative, interesting son.

"I thought it would be interesting to parallel the relationships between the Hatter and his father in Wonderland, and Alice and her mother upstairs," continued Bobin. "It's often a question of coming to some compromise. As ever, it becomes a film about family. Hatter's family is incredibly important to him, and Alice's quest is to try and save them."

"He's mad in a different way to Tarrant," said Ifans, whose character's name, Zanik, according to Woolverton, is "possibly" a nod to *Alice in Wonderland*'s late producer, Richard D. Zanuck. "He's very conservative and wants the best for Tarrant, to follow him in the family trade and do well. But Tarrant has other kinds of left field ideas, and they come to blows quite often. [He] feels Tarrant lets him down. But at the end of the day he's a loving, doting father who only wants the best for his son."

ABOVE: The paper hat the young Mad Hatter makes for his father. Designed by Dan Hennah and Ra Vincent; built by James Hendy and team.

BELOW: Hatter's father looks over the hat his son has made for him.

An Illustrated Journey Through Time

As Alice travels further into Underland's past, she uncovers the events that led to the near-irreparable damage between Iracebeth and Mirana, which started when they were young princesses, and involved jam tarts, an ill-fitting tiara, and a lie told by Mirana. We also finally discover why the Red Queen's head is so big. "You find out Iracebeth has a very sad backstory, and at moments you even feel sorry for her," said Hathaway. "You find out my character has been living with this terrible secret, and they're able to heal."

"Anybody that has a sibling can probably relate to where the one that has done something wrong doesn't really want to admit it," said Suzanne Todd, who produced the movie along with her sister Jennifer. "The White Queen does not admit what really happened, and it sets a course for the rest of their lives and their relationship. The Red Queen loses her temper and the King decides [she] is unfit to rule and passes on the crown to the White Queen, which is devastating to the Red Queen because it's all she's ever wanted, and she's the older sister.

"The White Queen knows it was her fault, and is overwhelmed with guilt and sorrow," added Todd. "It's a fork in the road in terms of how their relationship became so strained, as you saw it in the first film."

ABOVE: Iracebeth and Mirana as young girls with their mother

BELOW: The Red Queen and White Queen outside their childhood bedroom

PAGES 156–157: Anne Hathaway's White Queen and Helena Bonham Carter's Red Queen each pose with the Chronosphere in publicity shots from 2016's *Alice Through the Looking Glass*.

ABOVE: Concept illustration of Alice's English home. Artist: Michele Moen. Medium: Digital.

BELOW: Alice arrives home after years at sea.

WHILE Burton created his Underland as an all-digital environment, Bobin opted to build more sets, relying on blue screen (not green) and CG to extend or enhance them. For him, reality was key to both the fantasy and Victorian sections of *Alice Through the Looking Glass*. "I am a historian," he noted. "I studied history at university; I'm married to a historian. So I am slightly obsessed with the past. It needs to feel genuine."

The first goal was to create a real world that Alice could escape from. Movie magic, Bobin said, can become "the ultimate time-travel device. You can re-create nineteenth-century London, in London, and it's such a fantastic feeling to step onto set and see horses and horse manure and dirt. It feels like you're really there." Victorian London afforded Bobin and team the opportunity to cast huge numbers of people, all sooty and worn and under a darker sky. "I hate the idea of the past being pristine," Bobin finished. "But *Alice* is also about a sense of incredible wonder."

An Illustrated Journey Through Time

At the same time, Bobin wanted to pay respect to Burton's Gothic stylings and sensibility in *Alice Through the Looking Glass*. "We owe a debt to Tim's sense, generally, because he has a slightly Gothic feel to his work," Bobin observed. "Funnily enough, the Victorian times were the high period of Gothic, and there's an element of that retained, whatever we do, because of the design of the characters and of the world Tim came up with. But I like the idea you can add an element of historical accuracy. Plus magic; magic is always important to me."

Production designer Dan Hennah (The Hobbit series) describes the film's visual aesthetic as "fantasy Victorian. I don't want to say 'Victorian on acid,' but it certainly would be psychedelic Victorian. Even in the fantasy world, we tried to be true to the world of Lewis Carroll, the period of Lewis Carroll, that Victorian period. The temptation was to go steampunk, but we tried to stay away from that just because it's been done. [The aim] was to find a fantastic world that was surreal and beautiful, because it is a beautiful story."

ABOVE: Concept illustration of the asylum. Artist: Unknown. Medium: Digital.

BELOW: Concept illustration of Alice escaping the asylum. Artist: Unknown. Medium: Digital.

ABOVE AND OPPOSITE: Concept illustrations of Witzend. Artist: Anthony Allan. Medium: Digital.

PAGES 162-163: Concept illustration of Marmoreal. Artist: Unknown. Medium: Digital.

Alice Through the Looking Glass's Underland also has more of a "human populous" than before. This is never more evident than in Witzend, home to the Hatter family, King Oleron (Richard Armitage) and Queen Elsemere (Hattie Morahan), as well as the two princesses, Iracebeth and Mirana. One of the film's major sets, consisting of several streets, a crossroad, shops, houses, and a castle, Witzend was built on a soundstage at Shepperton Studios, near London. Its thatched roofs and limestone buildings are partly inspired by those in the Cotswolds, in central England. "It feels like old-town Dubrovnik [in Croatia] meets the Cotswolds," revealed Bobin. "But I said to Dan, 'Push it that extra [bit] into the magical realm, whereby trees grow on roofs and you have curved edges, and none of the actual perspective or actual architecture make sense in terms of their design because they should all fall over.'"

Moreover, Bobin wanted Witzend to have an enchanted quality. "Like all of your memories of the best summer's day of your childhood," noted Hennah. "The palette was chosen to enhance that feeling of a summer's day, the lightness, the brightness, the beauty of it all. It's a place you don't want to see destroyed, a place where everybody has fun. It has a very whimsical feel to it."

Film-inspired original illustration of Alice approaching Time's castle. Artist: Laurent Ben-Mimoun. Medium: Digital.

OPPOSITE, BOTTOM: Concept illustration of Time's castle exterior. Artist: Ra Vincent. Medium: Digital.

ABOVE: Concept illustration of Time's castle interior. Artist: Laurent Ben-Mimoun. Medium: Digital.

Another massive environment was Time's castle, although this was mainly a CG creation. "In the script it was described as being infinite, and infinite externally and internally," said Hennah. "Infinity is a hard thing to illustrate. What we did was come up with concept work that showed a castle that stretched up into the clouds, and when we went inside, infinity would go downwards, as well as upwards, as well as away from you into the depths of the castle."

Hennah and his team decided that Time's clock, being the story's centerpiece, would essentially become the castle itself. The castle's design was filled with huge machinery; the further you travel into this enormous palace, the closer you come to Time's power source.

"James [Bobin, the director] had this lovely idea that Time would be like a janitor, and he'd have this little janitor's closet full of curios, like one of these fabulous curiosity cabinets people in Victorian times had," Hennah recounted. "So there was this great contrast between the mechanism of the castle and Time's lovely little closet." And even here Bobin was striving for realism. "It's a wonderfully beautiful, fantastical, magical environment, but the design cues are from various fourteenth-century cathedrals across Europe," he said. "You can use both elements, history and magic, to make something really interesting."

While *Alice Through the Looking Glass* shares only a title and a handful of ideas and characters

THIS SPREAD: **Concept illustration of Alice entering Time's throne room.
Artist: Rick Buoen. Medium: Digital.**

INSET: **Time on his throne**

ABOVE: Concept illustration of the Oceans of Time. Artist: Rick Buoen. Medium: Digital.

OPPOSITE: Concept illustration of an idyllic day in Marmoreal. Artist: Michele Moen. Medium: Digital.

> "We're here to make fans of the first [film] happy . . . to get them to believe in impossible things."
>
> —Anne Hathaway (White Queen)

with Carroll's book, Bobin felt that the film contains both the spirit of the author and some of his language. "Whenever I can, I drop in lines from him because I think his dialogue is so brilliant and so beautifully put together," he revealed. "For me, Lewis Carroll was talking about his own time and his own society, and it's satirizing a lot of Victorian society's ways of working and the ways the world worked.

"That was very clever," said an admiring Bobin. "It feels you can trace a direct lineage from Lewis Carroll to Edward Lear to *The Goon Show* to *Monty Python*, this very English sense of humor. I'm from the comedy world; I think Lewis Carroll is one of the inventors of surrealist comedy, and to bring elements of that to this was very important to me. It's a mixture of the Lewis Carroll underpinning, plus the Tim Burton world from the last movie."

"The thing that we're all here for is to make the fans of the first one happy," concluded Hathaway, "and especially kids, because this film really resonated with kids. I have had a lot of young people come up to me and [say], this [the 2010 *Alice*] is one of their favorite films, and so we just want to take them further into the journey, [to] get them to believe in impossible things, and get them to believe that they have *muchness*.

"Those are two such wonderful concepts to put out there into the world," Hathaway emphasized. "And then, hopefully, make it an entertaining film. The first film accomplished that, and I think there's a really good chance the second one will, too."

Selected Bibliography

Books

Bossert, David A. *Disney & Dali: Destino: The Story, Artwork, and Friendship Behind the Legendary Film.* Los Angeles • New York: Disney Editions, 2015.

Canemaker, John. *The Art and Flair of Mary Blair: An Appreciation.* New York: Disney Editions, 2003; reissued 2014.

———. *Walt Disney's Nine Old Men and the Art of Animation.* New York: Disney Editions, 2001.

Douglas-Fairhurst, Robert. *The Story of Alice: Lewis Carroll and the Secret History of Wonderland.* London: Harvill Secker, 2005.

Gabler, Neal. *Walt Disney: The Triumph of American Imagination.* New York: Alfred A. Knopf, 2006.

The Annotated Alice. Ed. Martin Gardner. London: Penguin, 2001.

Hollis, Richard, and Brian Sibley. *The Disney Studio Story.* London: Octopus Books, 1988.

Iwerks, Leslie, and John Kenworthy. *The Hands Behind the Mouse.* New York: Disney Editions, 2001.

Maltin, Leonard. *The Disney Films, Fourth Edition.* New York: Disney Editions, 2000.

Merritt, Russell, and J. B. Kaufman. *Walt in Wonderland: The Silent Films of Walt Disney.* Baltimore, Maryland: The Johns Hopkins University Press, 1994.

Miller, Diane Disney (as told to Pete Martin). *The Story of Walt Disney.* New York: Holt, 1957; Disney Editions, 2005.

Salisbury, Mark. *Alice in Wonderland: A Visual Companion.* New York: Disney Editions, 2010.

Smith, Dave. *Disney A to Z: The Official Encyclopedia, Fourth Edition.* Los Angeles • New York: Disney Editions, 2015.

Surrell, Jason. *Screenplay by Disney: Tips and Techniques to Bring Magic to Your Moviemaking.* New York: Disney Editions, 2004.

Susanin, Timothy S. *Walt Before Mickey: Disney's Early Years, 1919–1928.* Jackson, Mississippi: University Press of Mississippi, 2011.

Thomas, Bob. *Disney's Art of Animation: From Mickey Mouse to Beauty and the Beast.* New York: Hyperion, 1991.

Articles and Other Sources

Alice in Cartoonland by Walt Disney: 35 mm Collector's Set. Dir. Walt Disney. Disney Brothers/Winkler Pictures, 1923–1927, Kit Parker Films, 2007. DVD.

Alice in Cartoonland: The Original Alice Comedies by Walt Disney. Dir. Walt Disney. Disney Brothers/Winkler Pictures, 1925–1927, Inkwell Images, 2007. DVD.

Alice in Wonderland (2010) production notes.

Alice in Wonderland: 60th Anniversary Edition. Dir. Clyde Geronimi, Hamilton S. Luske, and Wilfred Jackson. Walt Disney Studios Home Entertainment, 1951. Blu-ray.

Barrett, Melissa, and David Johnson. Classic No. 13 Alice in Wonderland (1951). *TheDisneyOdyssey.WordPress.com*. February 12, 2014. Web.

Crowther, Bosley. *Alice in Wonderland* film review. *New York Times*, July 30, 1951.

Disney, Walt. "How I Cartooned 'Alice': Its Logical Nonsense Needed a Logical Sequence." *Films in Review*. Volume II, Number 5. May 1951. Pages 7-11.

Donald in Mathmagic Land. Dir. Hamilton S. Luske and Joshua Meador. Walt Disney Studios Home Entertainment, 1959, 2009. DVD.

Internet Movie Database. *imdb.com*. Web.

Janzen, Jack and Leon, "Disney Show Designer Claude Coats," *The "E" Ticket*, No. 31, Spring 1999.

Mallory, Michael. "Virginia Davis and the Road to Hollywood." *AnimationMagazine.net*. February 16, 2012. Web.

Pickavance, Mark. "Looking Back at Disney's Alice in Wonderland: Refining the Animator's Craft." *DenofGeek.com*. February 28, 2011. Web.

Pointer, Ray. "The Alice Story." *InkwellImagesInk.com*. Undated. Web.

Polsson, Ken. "Chronology of the Walt Disney Company." *kpolsson.com/disnehis*. February 27, 2015. Web.

Seegar, Alan. "Down the ol' Rabbit Hole: Remembering the Original 'Alice in Wonderland' Attraction 1958-1982." *Persistence of Vision*. Volume I, Number 3. Spring 1993. Pages 44-46.

Through the Keyhole: A Companion's Guide to Alice in Wonderland. Dir. EMC West. Walt Disney Studios Home Entertainment, 2011. Blu-ray.

Sherwin, Jill. "Show Spotlight: The Mad T Party." *Mousertainment.WordPress.com*. January, 19, 2015. Web.

Walt Disney Productions, Press Release #22563: "Walt Disney Had A Special Knack For Inspiring His Animators." *Alice in Wonderland* (1974, rerelease). 2 pages.

Walt Disney Treasures: Mickey Mouse in Living Color, Volume Two. Buena Vista Home Entertainment / Disney, 2004. DVD.

Walt Disney Treasures: Disney Rarities: Celebrated Shorts, 1920s–1960s. Buena Vista Home Entertainment / Disney, 2005. DVD.

Interviews

Atwood, Colleen. Personal interview. May 12, 2015.
Bobin, James. Personal interview. June 5, 2015.
Burton, Tim. Personal interview. January 20, 2009.
Depp, Johnny. Personal interview. Walt Disney Studios electronic press kit interview.
Hathaway, Anne. Walt Disney Studios electronic press kit interview.
Hennah, Dan. Personal interview. May 13, 2015.
Hopper, Hedda. "Movie 'Alice' Revels in Disney Zany Land", *Los Angeles Times*, December 24, 1950. Section: SCREEN. Page: C4.
Wasikowska, Mia. Personal interview. November 17, 2008.
Woolverton, Linda. Personal interviews. January 9, 2010 and May 7, 2015.

Index

A

Absolem (caterpillar), 15, 76, 101, 106, *110*, 141, *141*, 144
Alice (1988), 122
Alice Comedies (Disney films), 12–43, *34*, *35*
 Alice and the Dog Catcher (1924), 32
 Alice Cans the Cannibals (1925), 33
 Alice Charms the Fish (1926), 41
 Alice Chops the Suey (1925), 36
 Alice Foils the Pirates (1927), 36
 Alice Gets in Dutch (1924), 33, *33*
 Alice Gets Stung (1925), 36
 Alice Hunting in Africa (1924), 30
 Alice in the Jungle (1925), 36
 Alice on the Farm (1926), 36
 Alice's Circus Daze (1927), 42
 Alice's Day at Sea (1924), 28, *29*, 30
 Alice's Egg Plant (1925), 36
 Alice's Fishy Story (1924), 31
 Alice Solves the Puzzle (1925), 31, 36, *40*
 Alice's Spooky Adventure (1924), 30, *30*, 31
 Alice Stage Struck (1925), 31, 33, *38*, *39*
 Alice's Wild West Show (1924), 30, 31
 Alice's Wonderland (1923), 21, 22, 23, 24, 25, 31
 Alice the Fire Fighter (1926), *31*
 Alice the Jail Bird (1925), 28, *28*
 Alice the Peacemaker (1924), 31, 32, *32*
 Alice the Whaler (1927), *43*
 Alice Wins the Derby (1925), *42*
Alice in Wonderland (1951), 46, 54, 55, 55–119, *56–59*, *69*, *81*
 as counterculture hit, 107
 "Disneyfying" characters for, 82
 finding correct character voices, 75, 76
 influence in theme parks, *110*, *111*, 112, 113
 mixed reviews of, 104, 106
 need for changes to Tenniel's artwork for film, 80, 82, 83
 need for plot structure in, 65
 Oscar-nominated music in, 80
 premiere, 104
 reduced number of characters in, 66
Alice in Wonderland (2010), 122–139
 character and personality changes in Alice in, 125, 126, 127, 128, 129
 follows Alice into womanhood, 141
 immediate success of, 134
 new visions of Wonderland in, 131, 132, 133
 Oscars awarded to, 134
 surrealism in, 129
 use of computer generation and motion capture, 133
Alice in Wonderland attraction, 70–73
Alice's Adventures in Wonderland (Carroll), 10, *14*, 15, *15*, 16, 18, 55, 65, *65*, 80, *131*, 148
 episodic nature of, 65
 influence and legacy of, 15, 16
 instant success of, 18
 need to reduce number of characters from for film, 66
 origins of, 18, 19
 told from child's perspective, 18, 19
Alice's Adventures in Wonderland (Porter), 19
Alice's Adventures Underground (Carroll), 18
Alice's Cartoonland (test film), 21
Alice's Curious Labyrinth, *94–97*
Alice's Tea Party attraction, 63, *63*
Alice Through the Looking Glass (2016), 16, 112, 128, 141–169
 Alice at sea in, 142
 Alice realizes identity in, 142, 143, 144
 concepts of time in, 148–149, 153
 re-creation of nineteenth-century London for, 158, 159
Allan, Anthony, 145, 146, 160
Anderson, Ken, 88
Angel, Heather, *86*
Armitage, Richard, 160
Arrow Development, 61
Ascot, Hamish, 126, 142, 144
Atwood, Colleen, 129, 130, 134

B

Barclay, Don, 83
Baron Cohen, Sacha, 148, *152*, *153*
"Baroque Hoedown" (song), 78
Bayard (dog), 125, *126*
Beaumont, Kathryn, 8, 71, *74*, 75,

75, 76, 82, *86*, 108, *108*
Ben-Mimoun, Laurent, 149, 164
Bergen, Edgar, 108, *108*
Bill, Leo, 126
Blair, Mary, 8, 64, 65, 66, 68, 82, 85–93, 104, 105, 106, 107, 112
Bobin, James, 10–11, 112, 128, 141, 143, 145, 146, 148, 149, 153, 154, 158, 159, 160, 165, 168
Bounds (Disney), Lillian, 30
Bunin, Lou, 104
Burton, Tim, 10, 16, 122, 125, 127, 129, 130, 131, 132, 133, 134, 159, 168
Bushman, Bruce, 60, 61

C

Carroll, Lewis, 8, 10, 11, 15, 16, *17*, 18, 19, 20, 21, 46, 48, 54, 55, 65, 66, 67, 75, 80, 82, 83, 104, 105, 106, 107, 112, 114, 122, 125, 126, 128, 129, 131, 134, 141, 146, 148, 153, 159, 168
Carter, Helena Bonham, 126, *127*, 133, 134, *135*, 155, *155*, 157
Caucus Race, 67
Cherniawsky, Todd, 132
Cheshire Cat, 15, *46*, 67, 75, 76, 78, *79*, *98*, 101, *101*, *126*, *132*, *136*, *138*
Chronosphere, *140*, 146, *147*, 148, *148*, *152*, *156*, 157
Cinderella (1922), *20*
Clark, Les, 100, *100*, 114
Clock Cleaners (1937), 108
Coats, Alan, 71
Coats, Claude, 70, 71
Colonna, Jerry, 75, *75*, 76
Conried, Hans, 108, 109, *109*
Cottrell, Bill, *54*, 55
Crowther, Bosley, 105

D

Dalí, Salvador, 98, *98*
David, Mack, 80
Davis, Lisa, 55
Davis, Marc, 8, 85, 98, 100, *100*
Davis, Virginia, 21, *22*, *23*, 27, 28, *28*, *29*, 32, *32*, 33, *34*, *35*, 36, *36*
Depp, Johnny, *123*, 129, *129*, 130, *130*, 133, 134, 144, 146, *147*
Dinah (cat), 87
Disney, Roy, 19, *19*, 25, 27, *27*, 28, *28*, 37, 41
Disney, Ruth, 41
Disney, Sharon, 108
Disney, Walt, 27, 30, 33, 36, 37, 41
 Alice Comedies and, 12–43
 buys rights to Tenniel's illustrations, 46
 combines live-action with animation, 20, 21, 32, 55, 114
 commits to entire animation, 33, 36, 55
 discovers animation, 19, 20
 and Disney Brothers Cartoon Studio, 26
 early career, 19–43
 first television show, 108, *108*
 at Gray's Advertising, 19
 insists on personalities in animation, 42
 interest in adapting *Alice's Adventures in Wonderland*, 46, 54, 55
 at Kansas City Film Ad Company, 19
 and Laugh-O-gram Films, 20, 21, 25
 moves to Hollywood, 26–28
Disney Brothers Cartoon Studio, 26, *30*

Disney California Adventure
 Mad T Party Entertainment, *136–137*
 World of Color show, *110*
Disneyland
 Alice-inspired attractions, *110*
 Alice in Wonderland attraction, 70–73
 Garden of Live Flowers, 70
 Mad Tea Party attraction, 60–63
 Main Street Electrical Parade, 78, 79
 Parade of Dreams, *110*
Disneyland Paris
 Alice's Curious Labyrinth, *94–97*
 Alice's Tea Party attraction, 60–63
 Main Street Electrical Parade, 78, 79
Disney Miller, Diane, 27, 108
Dodgson, Rev. Charles Lutwidge. *See* Carroll, Lewis
Dodo, 76, *132*, 133
Donald in Mathmagic Land (1959), 114–119
Door Knob, 68, *68*, 101
Dormouse, *113*, 133
Driscoll, Bobby, 108
Drury, John, 63
Duckworth, Rev. Robinson, 16
Duncan, Lindsay, 126

F

Fain, Sammy, 80
Felton, Verna, 76
Fleischer, Dave, 20, 25
Fleischer, Max, 20, 25
Forbes, Henry, 28
Freberg, Stan, 68
Freleng, Isadore "Friz," 41
Fry, Stephen, *126*

G

Garden of Live Flowers, 70, 88, *90*, 128

Gay, Margie, 36, *36*, *37*, *38*, *39*, *40*, 41, *41*, 42
Georgov, Walter, *76*
Geronimi, Clyde, 98
Gibson, Blaine, 71
Glover, Crispin, 133
Greet, W. Cabell, 75

H
Hall, David, 54, 55
Hamilton, Irene, 41
Hamilton, Rollin C. "Ham," 30, *30*, 32, 33, 41, *41*
Hand, Dave, 48, 49, *54*
Hardwick, Lois, 42, 43, *43*
Harlow, Joel, 130
Harman, Hugh, 21, 36, 41, *41*
Harper, Thurston, 33
Hathaway, Anne, *11*, 126, *126*, 130, *130*, 133, 146, 155, *155*, *156*, 168
Haydn, Richard, 76
Hee, T., *54*, 55
Hennah, Dan, 154, 159, 160, 165
Hilliard, Bob, 80
Hoffman, Al, 80
Holloway, Sterling, *75*, 76
Hong Kong Disneyland
 Mad Hatter Tea Cups attraction, 63, *63*
Hopper, Hedda, 65, 66, 67
Humpty Dumpty, 10, 46, 66, 67
Huxley, Aldous, 55
Hyperion Studio, 41, *41*

I
Ifans, Rhys, 154
Ising, Rudolph, 21, 36, 41, *41*
Iwerks-Disney Studio, 19
Iwerks, Leslie, 32
Iwerks, Ub, 19, 20, 21, *30*, 32, *32*, 33, 36, 41, *41*, 43

J
The Jabberwocky, 67, 68, 125, 127, *127*, 129, 133, 145
"Jabberwocky" (Carroll), 10, 19, 125
Jackson, Wilfred, 98
Johnston, Ollie, 100, *100*, 107
Julius (cat), 31, *31*, 36, 42, 43

K
Kahl, Milt, 8, 75, 80, 98, 100, *100*, 102
Kansas City Film Ad Company, 19, 20
Kawagiwa, Chris, 138
Kaycee Studios, 19, 20
Kenworthy, John, 32
Kimball, Ward, 76, 100, *100*, 101, 102, 106
King of Hearts, 53
Kline, Marty, 71

L
Laemmle, Carl, 43
Larson, Eric, 98, *100*, 101
Laugh-O-gram Films, 20, 21, 25, 26
Liddell, Alice, 10, 11, 18, *18*, 55, 129
Liddell, Henry George, 16
Livingston, Jerry, 80
Lounsbery, John, 98, *100*
Lucas, Matt, 133
Luske, Hamilton "Ham," 76, 77, 98, 114

M
Mad Hatter, 10, 15, *54*, *60*, 67, 76, *92–93*, *102*, *110*, *123*, 129, *129*, 130, *130*, *132*, *134*, 141, 144, 145, *145*, 146, *147*, 148, 154
Mad Hatter Tea Cups attraction
 Hong Kong Disneyland, 63, *63*
Mad Tea Party attraction, 60–64
Main Street Electrical Parade, 78, *79*
Malice in Wonderland (2009), 122
Mallik, Anne-Marie, 122

Maltin, Leonard, 106
March Hare, *54*, *60*, 67, 75, 76, 83, *83*, *99*, *102*, *131*, *132*, 133
Marcus, Mike, 28
Martin, Pete, 27
Maxwell, Carman "Max," 21, 36
McKim, Sam, 70, 71
Messing, Steven, 128, 133
Mickey Mouse, *32*, 43
 Thru the Mirror (1936), 46, 47–53
Miller, Jonathan, 122
Mintz, Charles, 30, 32, 33, 43
Moen, Michele, 142, 143, 158, 168
Morahan, Hattie, 160
Mr. Mouse Takes a Trip (1940), *31*

N
Nine Old Men, 98, 100, *100*
Nordberg, Cliff, 83, 102

O
The Ocean Hop (1927), *31*
O'Day, Dawn, 36
Olsen, Moroni, 108
O'Malley, J. Pat, 76
Oswald the Lucky Rabbit, 31, 43
Out of the Inkwell (Fleischer brothers), 20, 25, 30
Ozzimo, Paul, 149

P
Parade of Dreams, *110*
Parsons, Luella, 67
Patten, Luana, 55
Paul, Greg, 63
Peg Leg Pete, 31
Peraza, Mike, 138
Perkins, Al, 54, *54*, 67, 68
Philippi, Charles, 76
Pickford, Mary, 21, 36, 46
Pinocchio (1940), 46, *46*, 54
Porter, Edward Stanton, 19
Potter, Dennis, 55
Powers, Dermot, 138

Q

Queen of Hearts, 15, *47*, 53, 66, *66*, 76, *88*, 101, *101*, 126, *176*

R

Rackham, Arthur, 131
Raikes, Alice, 19
Ralston, Ken, 133
Red Queen, 19, 126, *127*, 129, 130, 133, 134, *134*, *135*, 149, 155, *155*
Reitherman, Wolfgang, 100, *100*, 114
Rogers, Ginger, 55

S

Scribner, Laurel, 138
Shanghai Disneyland
 Alice in Wonderland Maze, 138–139
Shen, Luca, 138
Snow White and the Seven Dwarfs (1937), 41, 46, 54, 70, 108
Spall, Timothy, 125
Stromberg, Robert, 132, 134
Sullivan, Pat, 25, 27
Surrell, Jason, 107
Susanin, Timothy S., 26
Svankmajer, Jan, 122

T

Tareekes, Alisara, 138
Tenniel, Sir John, 15, 16, 18, *18*, 19, 46, 54, 55, 65, 66, 80, 81, *81*, 82, 83, 88, 105, 125, 132
Thomas, Frank, 68, 98, *100*, 101, 107
Thompson, Bill, 76
Thompson, Jimmie, *76*
Through the Looking-Glass, and What Alice Found There (Carroll), 10, 15, 19, 46, 48, 67, 125

as allegorical device, 10, 141
popularity of, 19
Thru the Mirror (1936), 46, *47*–53, 98
Time, 148–153, *152*, 164, 165, *166–167*, 168
 as a person, 148
 changeless, 153
 enormous power of, 149
 finding, 11
Todd, Jennifer, 131, 155
Todd, Suzanne, 141, 155
Tokyo Disneyland
 Alice's Tea Party attraction, 63, *63*
 Electrical Parade, 78, *79*
Tulgey Wood, 68, 70, 88, 146, *146*
Tweedledee and Tweedledum, 10, 76, *76*, 101, *103*, 133, *133*
 introduction of, 19

U

"The Unbirthday Song," 78, 80

V

Vincent, Ra, 145, 154, 164
Vorpal Sword, 125

W

Wallace, Oliver, 80, *80*
Walrus and the Carpenter, 19, 68, *69*, 76, 83, *83*, 101
Walt Disney Studios, 41
Walt Disney World
 Alice-inspired attractions, *111*
 Mad Tea Party attraction, 62, *62*
 Main Street Electrical Parade, 78, *79*
Wasikowska, Mia, *11*, *122*, 125, 126, 127, *127*, 128, 133, 134, *140*, 143
Whitebait, William, 104
Whitehouse, Paul, 131
White Knight, 19, 46, 68
White Queen, *11*, 126, *126*, 130, *130*, 155, *155*, 168

White Rabbit, *54*, 67, 68, 76, *85*, *102*, *109*, *110*, *111*, 126, *133*
Winkler, Margaret J., 25, 26, 27, 28, 30, 31, 33, 41
Wonderland/Underland, 126, *128*, 131, *131*, 132, *132*, *133*, 148, 149, 158, 160
Wong, Allie, 138
Woodward, Marvin, 102
Woolverton, Linda, 10, 122, *122*, 125, 126, 127, 128, 129, 134, 141, 142, 143, 145, 146, 153, 154
World of Color show, *110*
Wynn, Ed, 8, *75*, 76

Y

Young, W. W., 19
Youngquist, Bob, 115

Z

Zanuck, Richard D., 154
Zhang, Danqing, 138

The Queen of Hearts onstage in front of the Magic Kingdom's
Cinderella Castle at Walt Disney World Resort